Postcard History Series

# Crystal Lake

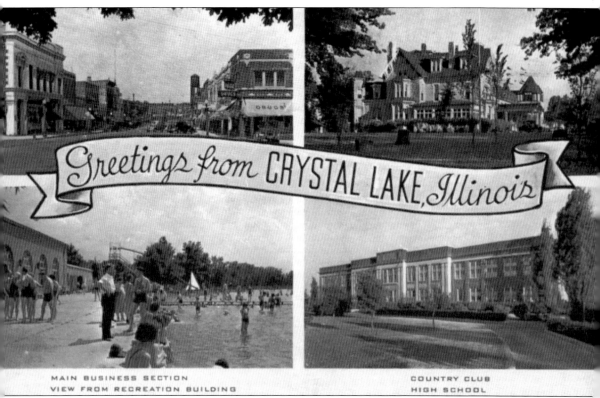

**GREETINGS FROM CRYSTAL LAKE.** This popular 1930s postcard was widely circulated. Thumbnail photographs of downtown Williams Street, the Main Beach recreation building, the Dole mansion/Crystal Lake Country Club, and the community high school depict scenes from throughout the community. (Courtesy of Jim Wyman.)

*On the front cover*: **SUMMER FUN AT CRYSTAL LAKE.** Generations of children have sought relief from hot summer days by swimming in the cool, clear waters of Crystal Lake. The Main Beach recreation building was constructed in 1926 at a cost of $40,000. The architect was Frederick Stanton, who also designed the country club addition to the Dole mansion. (Courtesy of the Crystal Lake Historical Society.)

*On the back cover*: **ALL ABOARD FOR CRYSTAL LAKE.** Mary Cadwell operated a horse-and-buggy taxi service between the train depot in Nunda and the resort hotels on Crystal Lake. She was an expert with horses, and she held the distinction of being the only woman in the county to conduct such a transportation system. Cadwell was well known for her charming personality and her reliable taxi service. (Courtesy of the Crystal Lake Historical Society.)

POSTCARD HISTORY SERIES

# *Crystal Lake*

*Diana L. Kenney for the Crystal Lake Historical Society*

ARCADIA
PUBLISHING

Copyright © 2009 by Diana L. Kenney for the Crystal Lake Historical Society
ISBN 978-0-7385-6007-6

Published by Arcadia Publishing
Charleston SC, Chicago IL, Portsmouth NH, San Francisco CA

Printed in the United States of America

Library of Congress Catalog Control Number: 2009922890

For all general information contact Arcadia Publishing at:
Telephone 843-853-2070
Fax 843-853-0044
E-mail sales@arcadiapublishing.com
For customer service and orders:
Toll-Free 1-888-313-2665

Visit us on the Internet at www.arcadiapublishing.com

*This book is dedicated to the citizens of Crystal Lake—past, present, and future—who make our community a good place to live.*

# Contents

| | | |
|---|---|---:|
| Acknowledgments | | 6 |
| Introduction | | 7 |
| 1. | Downtown Business District | 9 |
| 2. | Railroad History | 33 |
| 3. | Churches and Schools | 41 |
| 4. | Private Lakefront Resorts | 57 |
| 5. | Dole Mansion and Crystal Lake Country Club | 71 |
| 6. | Lakefront, Parks, and Recreation | 79 |
| 7. | Business and Industry | 99 |
| 8. | Street Scenes | 111 |
| About the Society | | 127 |

# Acknowledgments

*A country with no regard for its past will do little worth remembering in the future.*

—Abraham Lincoln

This book could not have been written without the permission, guidance, and encouragement of the Crystal Lake Historical Society Board of Directors. With very few exceptions, the images shown on these pages were obtained from postcards in the society's archival collection.

I wish to thank Nancy Fike, Major F. Gates, Sandy Price, Debby Schulz, Ann Viger, and Jim Wyman for their various contributions of time and resources to make this book a success. Additionally, I would be remiss if I did not mention the contribution of my family—Bill, Dan, and Laura—during the many weeks of writing this book. Thanks to each of you for your support and encouragement.

# INTRODUCTION

The city of Crystal Lake traces its roots to two separate and distinct communities that were both established in the 1800s. These communities were generally known as Crystal Lake and Nunda.

Prior to the establishment of these two communities, the earliest inhabitants of McHenry County were the Sauk (Sac) and Fox Indian tribes. Chief Blackhawk was an appointed war chief of the Sauk Indians. During the War of 1812, Blackhawk fought on the side of the British. At the end of the war, Blackhawk signed a peace treaty, reaffirming an earlier Native American one, which agreed to cede the land to the federal government and force all Native Americans to move west of the Mississippi River. Blackhawk later claimed he was unaware of all provisions in the treaty and began to mount a series of attacks to reclaim the lands of northern Illinois. After numerous skirmishes, battles, and massacres, Blackhawk was captured in 1832. The 1833 Treaty of Chicago ended the war and effectively removed the remaining Native Americans west of the Mississippi River.

The first settlers arrived in McHenry County in 1834. The county is named for Maj. William McHenry, an officer in the Blackhawk War. In 1836, the Illinois state legislature approved the establishment of McHenry County. The original county stretched east to Lake Michigan. The town of McHenry was declared the county seat, as it was near the geographical center of the county. Three years later, the county was divided into the two separate counties known today as Lake and McHenry. The McHenry County seat was later moved to Woodstock.

In 1835, several generations of the Beardsley family traveled together from New York State to McHenry County. They stopped briefly near the lake, where Ziba Beardsley is credited with saying, "the waters are as clear as crystal," thereby giving the lake its name. The Beardsley family did not stay but continued south to Naperville. When they returned to Crystal Lake in 1836, they found that Beman Crandall and his family had already established a home and were credited as the first settlers of Crystal Lake.

In February 1836, Beman and Polly Crandall and 6 of their 10 children came from New York State and traveled to Crystal Lake in a covered wagon. The family lived in the covered wagon and a three-sided shelter for a time until a log cabin could be built. Their original cabin was built in the vicinity of today's intersection of Virginia Street and Van Buren Street. Four of the Crandall children were born there.

The town was first known as Crystal Ville, and then the name was officially changed to Crystal Lake. In 1837, the first plat of the village of Crystal Lake was surveyed and drawn showing seven streets and 12 city blocks, including one block set aside as a public square (city park). This plat

was accepted by the McHenry County commissioners in 1840. The main business district for the village of Crystal Lake was located on Virginia Street, formerly an old Native American trail.

Soon more settlers arrived in the area. They were mostly hardworking farmers and their families who traveled by covered wagon from places such as New York and Virginia. Once here, they could purchase an 80-acre section of land at a price of $1.25 an acre. These farmers were the backbone of McHenry County.

The 1840 census shows 2,578 individuals lived in all of McHenry County. Besides Crandall, some other prominent Crystal Lake family names in 1840 include Baldwin, Beardsley, Douglass, Dufield, Duffy, Fitch, King, Lamphier, Peck, and Wallace.

Here are a few Crystal Lake firsts: Beman Crandall was the first postmaster and first justice of the peace; William Beardsley was the first white child born (1837); Hannah Beardsley was the first schoolteacher (1838), and her marriage to Franklin Wallace was the first one recorded in Algonquin Township (1840); the first hotel in Crystal Lake was built by Lyman King; the first public burying ground in Crystal Lake (and Algonquin Township) was the Crystal Lake Cemetery (1840), which is now known as the Lake Avenue Cemetery; the first burial in the cemetery was that of Ella King.

The area known today as downtown Crystal Lake was first called Dearborn and then Nunda. The village of Dearborn came into existence in the mid-1850s after the railroads extended their lines through the area. In 1856, the first train depot was established. This depot was prefabricated and shipped from Chicago on a flatcar. Although the depot was located near Dearborn, it was called the Crystal Lake station.

The railroad served to connect the people and industries of both Crystal Lake and Dearborn to Chicago and the rest of the county. Because of its proximity to the railroad, Dearborn's population and business district quickly grew.

On October 7, 1868, Dearborn's name was changed to Nunda after an area in New York from which many settlers had come. The village of Nunda was platted in 1868 by local surveyor John Brink. The village included the area now generally bounded by Route 176 on the north, Crystal Lake Avenue on the south, Main Street on the east, and Walkup Avenue on the west. Much of the land was originally owned by Daniel Ellsworth and Simon S. Gates.

The villages of Crystal Lake and Nunda were each incorporated in 1874, and they were often at odds with each other. There was constant feuding with a steady stream of accusations being thrown each way.

Two projects united the villages with a common goal. These projects were both appropriately preceded with the name Union. By 1883, the enrollment in both the Nunda School and Crystal Lake School had exceeded the capacity of the present school buildings. In an unprecedented effort, the often-feuding villages of Nunda and Crystal Lake came together and built the Union School. The school was located on McHenry Avenue between Paddock and Franklin Streets.

Five years later, the two villages again recognized the need to work together in order to purchase and provide a public burial ground for their citizens. The older Crystal Lake Cemetery was filling up. Each village contributed $750, and 10 acres of land was purchased on today's Woodstock Street. This became known as Union Cemetery. The central location of the property was ideal, as it was within the corporate boundaries of Crystal Lake, but in Nunda Township. In 1908, the name of the village of Nunda was changed to North Crystal Lake. Several attempts were made to consolidate the two villages. Finally, after much disagreement, the village of North Crystal Lake was annexed to the village of Crystal Lake in 1914, and a new city form of government was established.

The 20th century brought many changes and tremendous growth to Crystal Lake. Although it is now a bustling suburb of over 40,000 people, Crystal Lake has been able to retain its small-town charm and character through its restored and vibrant historic downtown district. The events and people of the past have truly shaped the community of today, as Crystal Lake continues to be a good place to live.

# One

# Downtown Business District

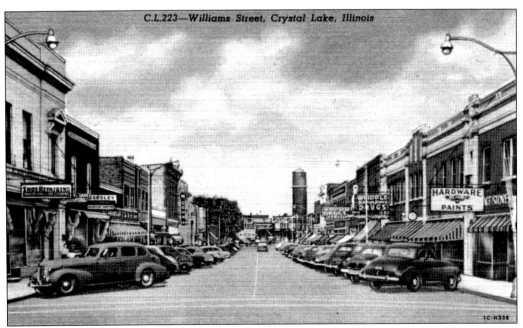

**WILLIAMS STREET.** Throughout history, the downtown business district has always been the heart of Crystal Lake. This is where citizens have gathered to shop, dine, and celebrate. The historic downtown business district centers around Williams Street, which is featured in many of the images found in this chapter. Today historic downtown Crystal Lake is still a thriving business district, thanks to the efforts of the local Main Street program.

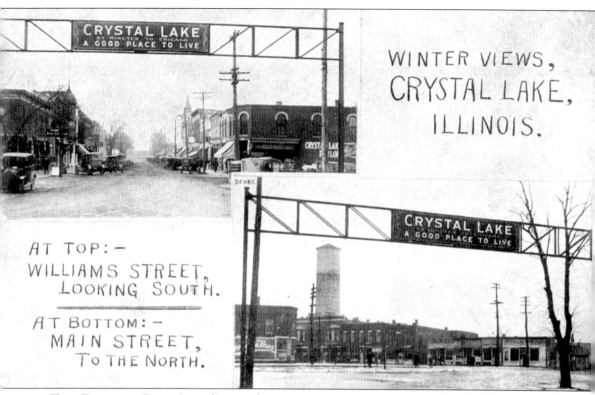

WINTER VIEWS, CRYSTAL LAKE, ILLINOIS.

AT TOP: — WILLIAMS STREET, LOOKING SOUTH.

AT BOTTOM: — MAIN STREET, TO THE NORTH.

**THE ELECTRIC SIGN.** According to the May 18, 1922, edition of the *Crystal Lake Herald*, an electric sign was erected across Williams Street. The sign was made possible through the efforts of the Crystal Lake Commercial Club (forerunner to today's chamber of commerce) to advertise the town to everyone who passed through either by rail or motorcar. The sign was two-sided and read, "Crystal Lake, a Good Place to Live, 55 Minutes To Chicago." The original sign is further described as "the main part of the wording is in large white letters which can be read easily for several blocks. The words, '55 Minutes To Chicago' are in gold leaf. All of the wording is against a dark green background and show up plainly in the daylight. The interior has 80 electric lights. The sign was lit every evening from dusk until 10PM. The sign is 4 feet high and 18 feet in length. It is mounted on structural iron posts 25 feet high. Total cost $741.17."

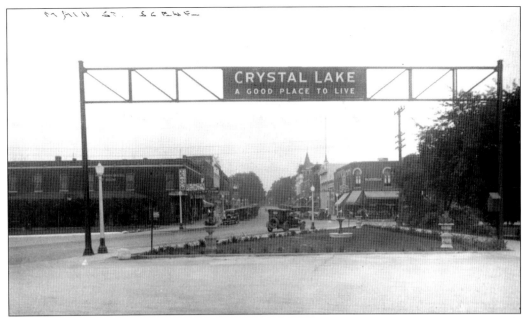

**THE ELECTRIC SIGN IS MOVED.** In 1924, the configuration of Williams, Main, and Woodstock Streets was altered. A triangle-shaped park was installed at the head of Williams Street, and the electric sign was moved 40 feet south of its original location. Moving the sign without going through the trouble and expense of dismantling it was no small task. New concrete footings were put in place, and then a large derrick crane was brought in to lift the three-ton sign and place it down on its new footings. The sign was moved without mishap except that one letter was broken when the end of a chain swung into it.

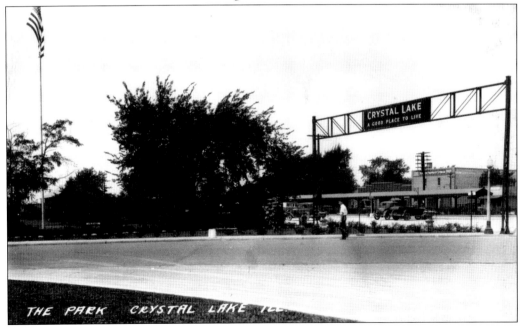

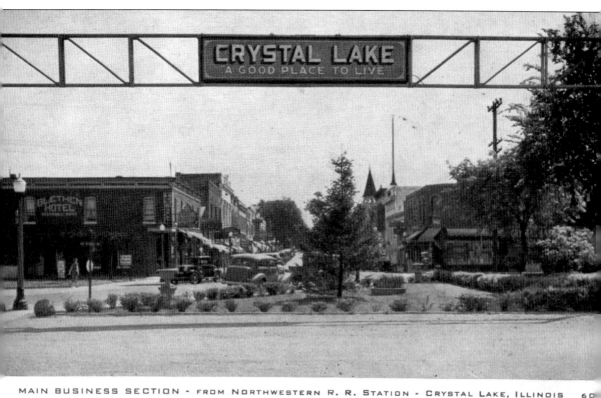

MAIN BUSINESS SECTION - FROM NORTHWESTERN R. R. STATION - CRYSTAL LAKE, ILLINOIS

**A Fond Memory, but the Slogan Lives On.** By the 1930s, the sign was redone. The electric part of the sign appears to have been removed, and it became just a sign. The new sign is still mounted on the same framework and is still located near the triangle-shaped park at the head of Williams Street. The print, style, and colors of the sign were changed several times through the years. By the early 1970s, the configuration of Woodstock Street was changed again, and the 50-year-old sign was removed. The removal of an old hotel building allowed for the straightening of Woodstock Street between Williams Street and Main Street. Herbert A. Dodge, a prominent citizen and civic leader, coined the phrase, "Crystal Lake—A Good Place to Live." More than 80 years later, the slogan is still used by the city of Crystal Lake.

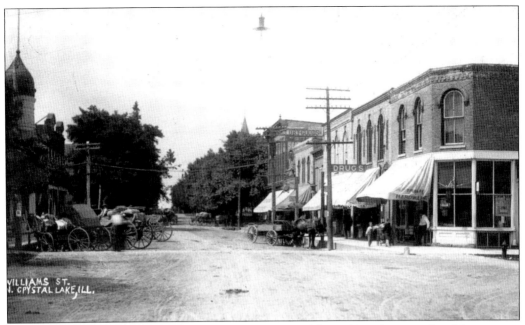

EARLY IMAGES OF WILLIAMS STREET. Perhaps some of the earliest photographs of downtown, these images show the north block of Williams Street shortly after the dawn of the 20th century. The street is unpaved and lined with hitching posts, as horses, buggies, and wagons were the primary means of transportation. Business buildings on Williams Street stopped mid-block, with residences filling the remainder of the street. On the right side and in the background, one has a glimpse of the steeple from the old Methodist Episcopal church, which stood at the southwest corner of Williams Street and Brink Street (see chapter 3). The street was lit by single lightbulbs strung by wire across the road. The first electric generator in the community was put into use by Henry H. McCullom in 1894.

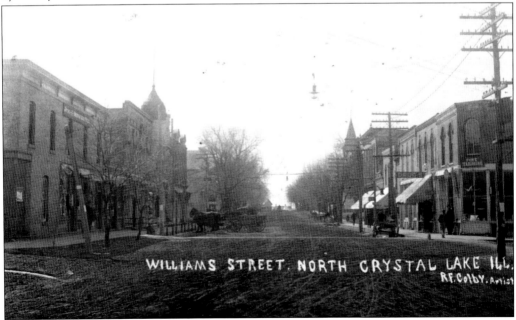

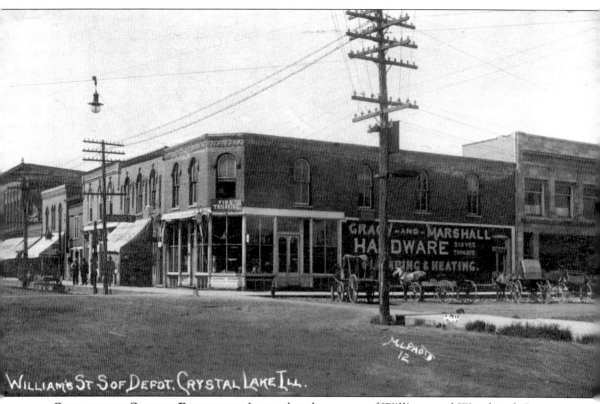

ONE OF THE OLDEST BUILDINGS. Located at the corner of Williams and Woodstock Streets, the Gracy and Marshall building is most likely the oldest standing structure on the block. This Italianate building is believed to have been built in the 1880s. It became home to John Marshall's hardware store in the 1890s. After Marshall's death in 1903, his young widow, Margaret, continued operation of the hardware store in order to support herself and four children. A few years later, she met and married Royal Gracy. The Gracys continued to operate the hardware store as well as various other businesses in the downtown district, including the first movie theater, which was located on the second floor of the building just south of the corner. The Gracy and Marshall building has been home to an ice-cream parlor, a drugstore, and several restaurants.

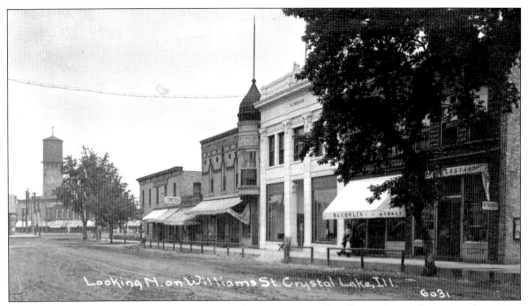

**THE EAST SIDE OF THE NORTH BLOCK.** This 1910 view of Williams Street features a clear view of the hitching posts that once lined the street. The white building in the middle is the Warner building, which was constructed in 1909. The building's facade is white enamel terra-cotta, which was manufactured locally. Roy Warner was the local mortician and furniture dealer. The entire first floor of the building was the furniture store. The second floor had a casket room and chapel. Also, the Warner family lived in an apartment on the second floor. Behind the trees in the above photograph is the building shown below. Notice the parapets at the top of the building. It still stands today, but the parapets have disappeared.

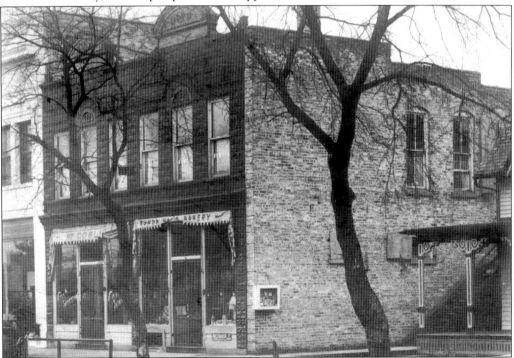

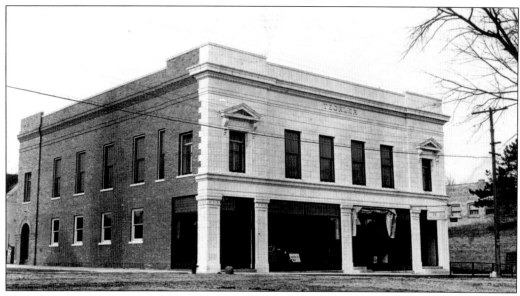

**THE TECKLER BUILDING.** Located at the corner of Williams and Brink Streets, this classical revival–style building was constructed in 1910 by Charles L. Teckler, an early real estate tycoon. The second-floor banquet/meeting hall was designed and built with no pillars or posts in the center of the large room. The facade facing Williams Street is glazed terra-cotta.

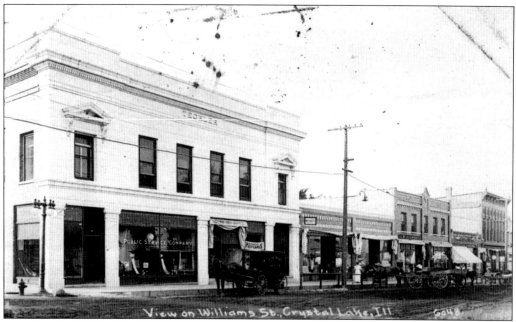

**EARLY BUSINESSES.** The first floor of the Teckler building housed several businesses, including Teckler's real estate office, the public service company, a dentist, a grocery store, a photograph shop, and a millinery shop. During the 1960s, the building was home to Crystal Lake Savings and Loan. Heisler's Bootery occupies the majority of the first-floor space today and has been in business in downtown Crystal Lake since 1908.

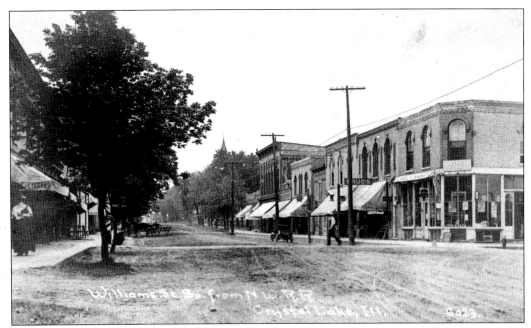

**SHARING THE STREET.** As early as 1899, horses, pedestrians, and automobiles had to learn to share the streets. This was not always an easy task, as horses became skittish and pedestrians were not used to vehicles traveling at high rates of speed. A 1904 ordinance set the speed limit for automobiles to eight miles per hour.

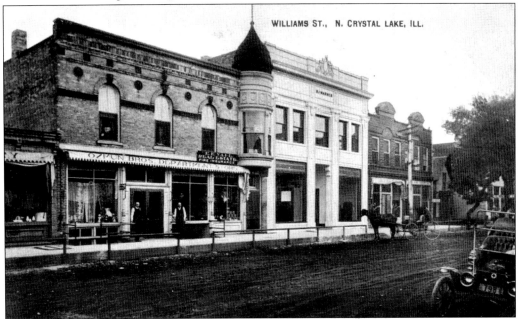

**BUILDING FACADE CHANGES.** The building on the left was owned by Ziba H. Osmun, who started his general mercantile business in the late 1800s. His brother G. H. Osmun eventually joined the firm. The photograph shows the original upper-story facade that included arched windows. These have since been replaced with rectangular windows. Decorative terra-cotta medallions adorn the facade. The Queen Anne–style turret was removed in the 1940s.

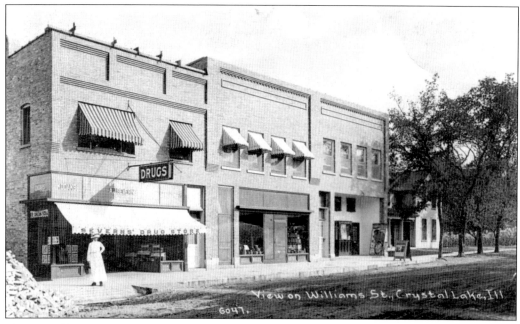

**TRIO OF 1912 BUILDINGS.** A. J. Severns's drugstore occupied the first building. In later years, it became Althafer's Pharmacy. The middle building was a general merchandise store that later became the Raue Hardware Store. The third building was first known as the Crystal Theatre. This photograph was taken in 1913, as evidenced by the pile of bricks (far left) that were being used to build the Gem Theatre building.

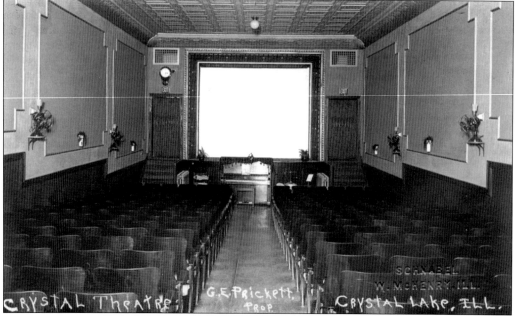

**A RARE LOOK INSIDE.** Guy E. Prickett and C. H. Paine built the Crystal Theatre in 1912 to bring a "better class of moving pictures" to Crystal Lake. Seating capacity was 300. The screen at the front of the theater was approximately 12 feet wide and 10 feet high. Admission was 5¢ and 10¢.

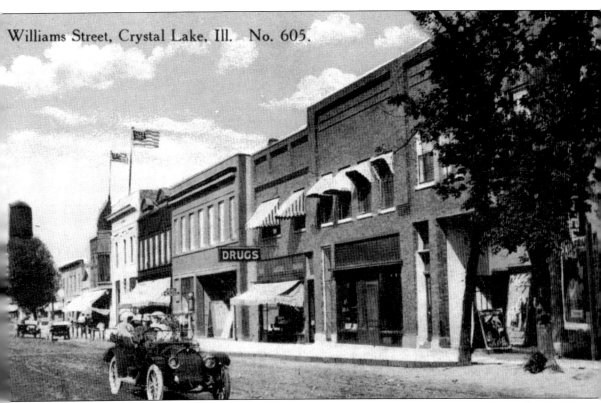

*Williams Street, Crystal Lake, Ill. No. 605.*

**TOO MANY THEATERS.** Less than a year after the Crystal Theatre opened its doors, Royal and Margaret Gracy relocated their movie house business from across the street to the much larger space on the east side of the street (the building to the left of A. J. Severns's drugstore). The Gracy's Gem Theatre occupied the entire first floor of the building. This move marked the eventual demise of the Crystal Theatre, which closed its doors in 1917. Left as the only movie house in town, the Gem Theatre remained open until 1929, when the El Tovar Theatre was built one block south on Williams Street. In 1929, the old Gem Theatre building was sold and remodeled. The building was leased to the Atlantic and Pacific Tea Company. In later years, it became a paint and wallpaper store.

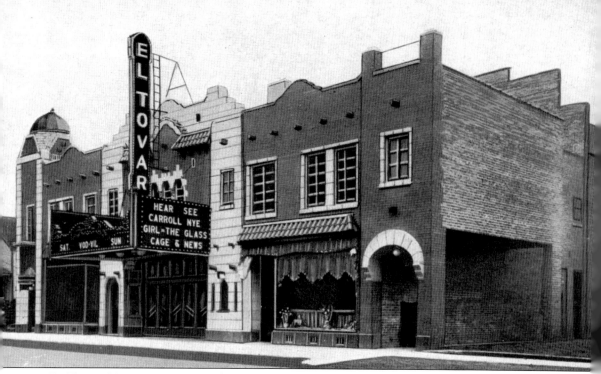

**El Tovar Theatre Opens.** This 1929 Spanish mission–style theater was designed by architect Elmer Behrns. While the Gem Theatre was a silent movie house, the El Tovar Theatre was built to play talkies. Total construction cost in 1929 was nearly $200,000. When the El Tovar opened, Margaret Gracy closed her Gem Theatre and was hired as the first manager of the El Tovar. The theater operated for many years. In later years, it was known as the Lake Theatre and the Showplace Theatre. Through the years, the building's condition deteriorated. Today without the Raue family, the historic theater on Williams Street would be dark, empty, and closed. In 1996, money from the Lucile Raue estate was used to purchase the old building. The vision was to rehabilitate it to create a visual and performing arts center. The old El Tovar Theatre was renamed the Raue Center for the Arts. Most of the significant, historic elements of the El Tovar have been retained, restored, or rebuilt.

**ARMISTICE DAY ON WILLIAMS STREET.** On November 11, 1918, the armistice was signed between the Allies and Germans, marking the official end of World War I. Like thousands of other towns all over the country, Crystal Lake held two celebrations commemorating the signing of the armistice. The first celebration started when early news reports first came over the wire that the Germans had signed the armistice. Stores, businesses, and schools closed, and everyone flocked downtown to celebrate. An impromptu parade of schoolchildren and adults gathered near the train depot and marched down Williams Street. Three days later, an organized parade of decorated automobiles, bands, and marchers once again paraded downtown. The day ended with a huge bonfire built at Depot Park for the purpose of burning the kaiser in effigy.

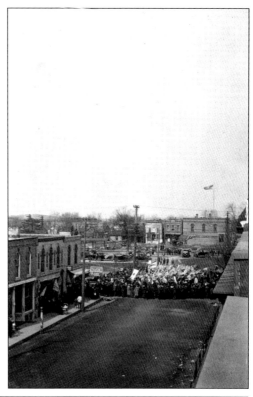

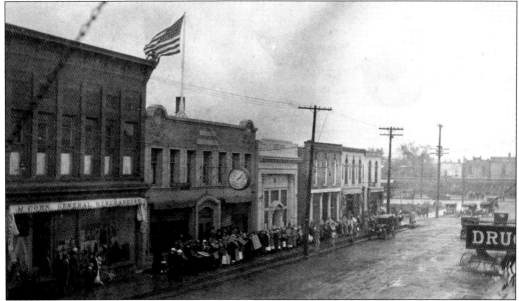

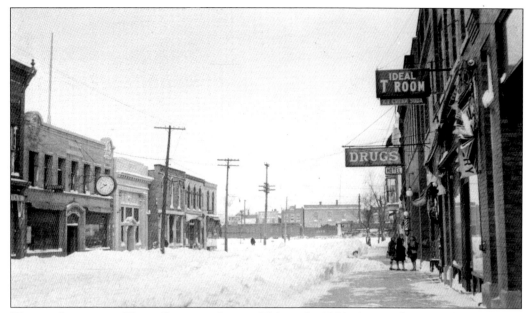

HEAVY SNOWFALL HITS CRYSTAL LAKE. This early-1920s image shows Williams Street shortly after a heavy snowfall. Notice the sidewalks have been cleared but not the street. Today the street is cleared first and the sidewalks later. A 1922 newspaper advertisement for the Ideal T(ea) Room announced, "Special $1.25 Chicken Dinners," which included soup, salad, entrée, rolls, dessert, and beverage.

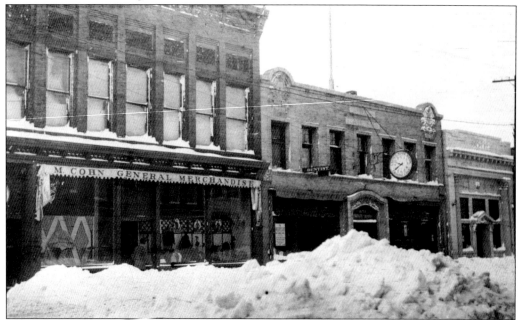

BEYOND THE MOUNDS OF SNOW. Through hard work and industry, Morris Cohn, a Russian-born immigrant, built one of the most successful retail businesses in Crystal Lake and eventually owned many of the structures on Williams Street. At Cohn's store, one could buy anything from shoelaces to small musical instruments. The building to the right of Cohn's is the United State Bank building (prior to the columned terra-cotta facade addition).

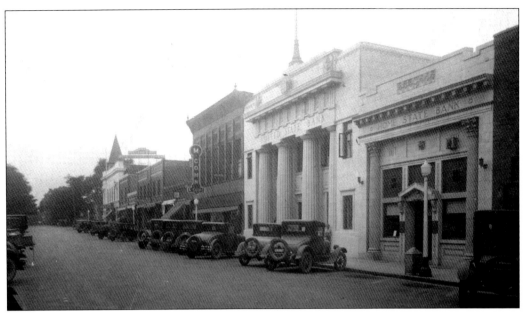

PROMINENT BANK BUILDINGS. Perhaps the most distinctive buildings on the block, with their decorative terra-cotta facades, are the United State Bank building (left) and Home State Bank building. The United State Bank operated in downtown Crystal Lake from 1916 until 1931, when it was deemed insolvent. Many Crystal Lake residents lost money due to the bank closing. The Home State Bank building was constructed in 1916. Home State Bank operated its financial institution in this small building until the 1940s when it moved into the larger, vacant United State Bank building. Home State Bank remained on Williams Street until 1961, when it moved to its current location on Grant Street. The image below provides a glimpse of the business directly north of the Home State Bank building, which was the National Tea Grocery store.

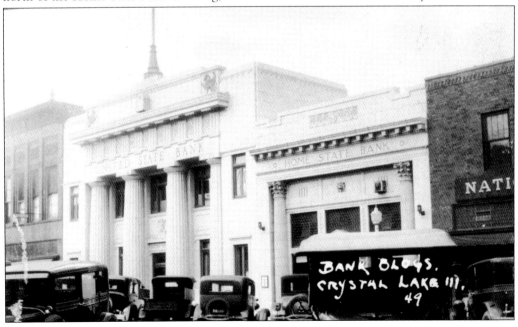

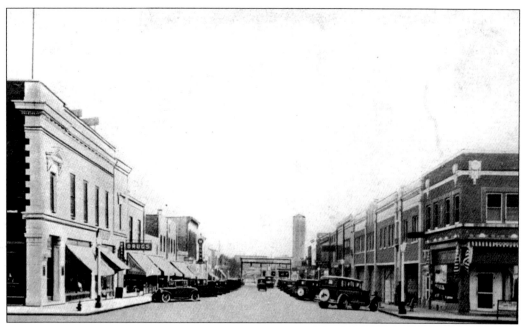

LOOKING NORTH FROM BRINK STREET. By 1930, North Williams Street was paved and lined with curbs. The two-way street was used exclusively by automobiles. The corner structure on the right is known as the Beatty building. In 1930, the Corner Shop was open for business in the Beatty building, offering a complete line of ready-to-wear clothing for women and children.

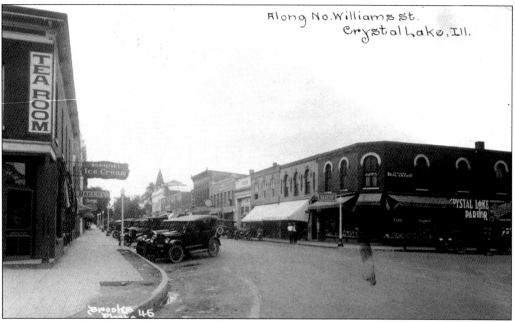

LOOKING SOUTH FROM WOODSTOCK STREET. At the other end of the block, the Crystal Lake Ice Cream Parlor occupied the Gracy and Marshall building. The first building on the left was the Blethen Hotel and Tea Room. This photograph shows how the east and west legs of Woodstock Street did not line up with each other at Williams Street.

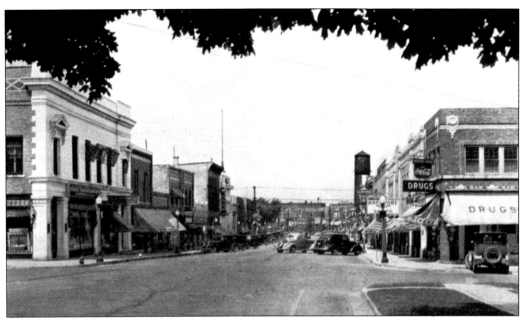

BUSINESS IS BOOMING. This 1938 postcard shows Williams Street looking north of Brink Street. A drugstore occupies the Beatty building on the corner. Farther up the block are a hardware store, a restaurant, a bakery, a jewelry store, and a grocery store. Williams Street was the center of commerce in Crystal Lake. By 1940, the city's population reached 3,917 people.

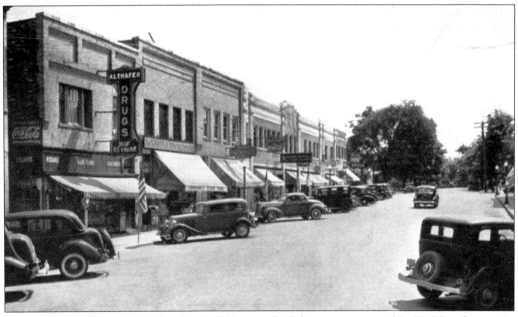

THE SEVERNS BUILDING. The first building on the left was constructed in 1912 by pharmacist A. J. Severns. In 1928, Oscar J. Althafer purchased the business and building. Althafer's Pharmacy was an established business on Williams Street for many years. Its slogan was "Home of Everything in Drugdom." Notice the flags standing upright on poles at the curb. These flags lined both sides of this block of Williams Street.

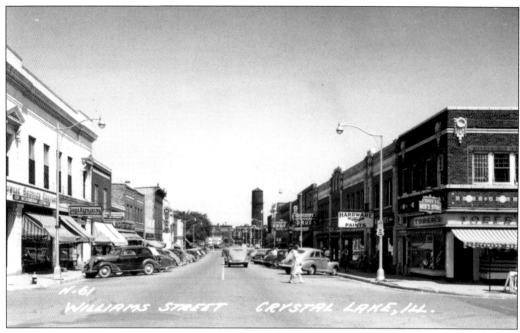

**HISTORY REPEATS ITSELF.** Today's downtown parking woes on Williams Street appear evident in these 1950s photographs. Signs indicate that parking is limited to two hours and U-turns are not permitted. The shorter, vintage streetlights have been replaced with tall, modern structures. Business use in some buildings remains the same. In the above photograph, there is a shoe repair shop on the left, just as there is today. In the photograph below, there is a restaurant at the corner of Williams and Woodstock with a bar two doors south. Likewise, business use has changed in many other buildings. Just past Whipple Drugs in the photograph above is a sign shaped like a bowling pin. This eight-lane bowling alley was owned by William Metropulos. A few years later, Metropulos moved his business around the corner to Brink Street and called it Metro Bowl.

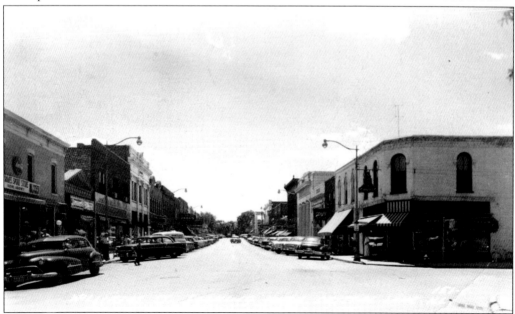

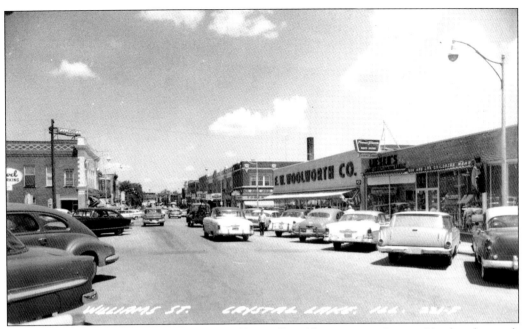

**SOUTH BLOCK CHANGES.** Through the efforts of local businessman Lester Gieseke, the south block of Williams Street transitioned from a residential block to a business block in the 1950s. Gieseke purchased numerous properties on the block, including the old Methodist Episcopal parsonage that was moved and replaced by an F. W. Woolworth's store.

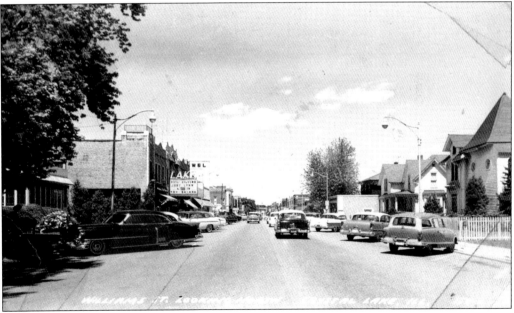

**ACROSS THE STREET.** The west side of Williams Street also saw changes. The old Methodist Episcopal church was purchased by Gieseke and demolished to make way for a Jewel Food Store. This was the largest food store in McHenry County, boasting over 100,000 items on its shelves. It was located just north of the Lake Theatre (El Tovar Theatre). Business at the Lake Theatre was booming at the time.

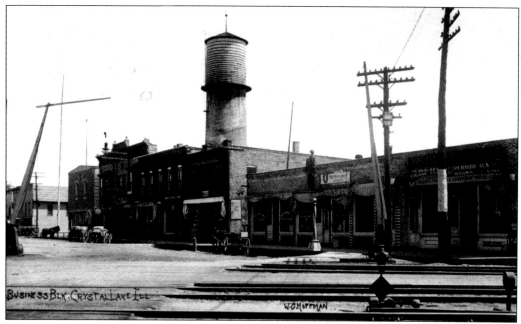

NORTH OF THE TRACKS. Some of the oldest downtown buildings are on Main Street just north of the tracks. The railroad played a vital role in the growth of downtown businesses. One could stop and pick up a variety of items, including newspapers, cigars, souvenir postcards, periodicals, and books before catching the train to Chicago.

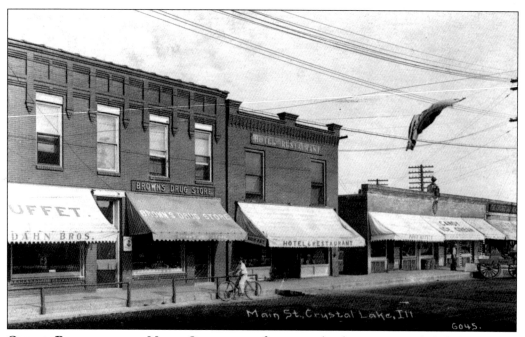

OTHER BUSINESSES ON MAIN. On a sunny afternoon, shopkeepers extended their awnings to shade their storefronts. This extra bit of signage provides clues to the building's use. This postcard is dated 1915. Notice Main Street is still a dirt road. Horses, wagons, cars, and bicycles are sharing the street.

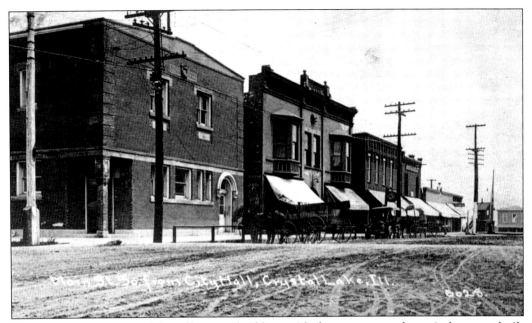

**THE MUGGE BUILDING.** The tall, center building with the upper-story bay windows was built in 1902 by J. Frederick Mugge. The second floor is an open area, originally called Concordia Hall. In 1909, it was known as the Crystal Lake Opera House. The first floor has been home to many businesses, including Meier's meat market and grocery store.

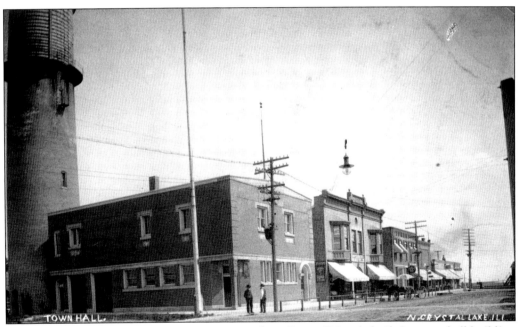

**TOWN HALL AND WATER TOWER.** In 1906, the village of Nunda built its town hall building at the corner of Main and Beardsley Streets. This building remained as the government offices after the merger of Nunda and Crystal Lake in 1914. Built in 1900, the village water tower was located on Beardsley Street. The water tower was 104 feet high and had a 65,000-gallon capacity. It was demolished in 1955.

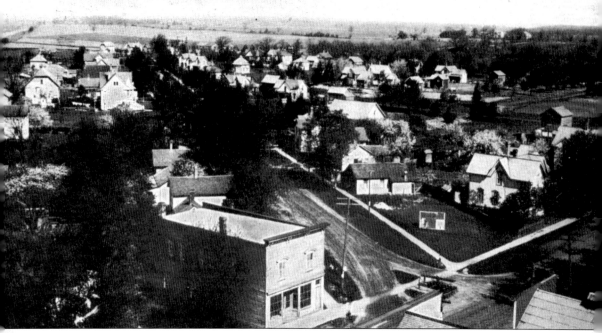

**LOOKING NORTHWEST FROM WATER TOWER.** Besides water storage, the water tower afforded some early aerial views of North Crystal Lake (Nunda). The dirt road seen here is Gates Street at its intersection with North Main Street. Many of the houses and carriage barns shown in this 1910 photograph are still standing today.

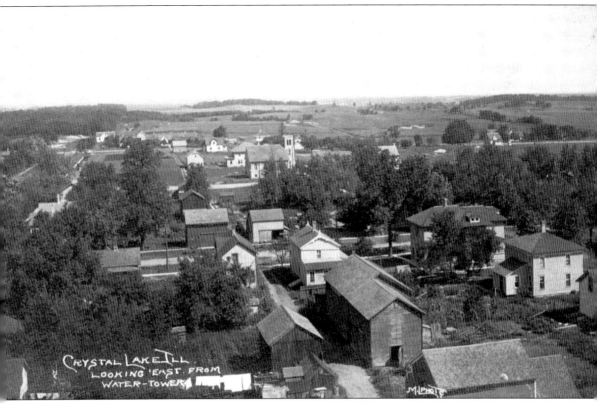

**LOOKING NORTH FROM WATER TOWER.** This part of the village is not quite as crowded. The road that runs from left to right in the distance is Terra Cotta Avenue (Route 176). North of Terra Cotta Avenue, farmlands stretch as far as the eye can see. In the center of the photograph is a stone church with a steeple. This is the old St. Paul's Church on Ellsworth Street.

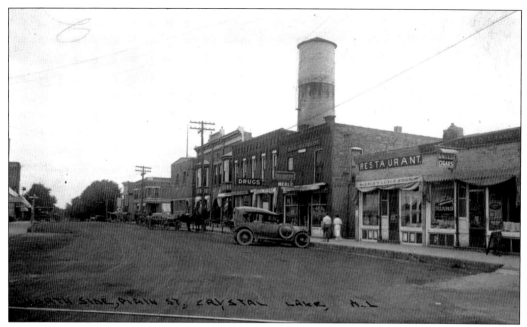

**THE 20TH CENTURY.** At the dawn of the 20th century, the business and residential buildings along North Main Street were primarily constructed of wood. On September 21, 1900, a disastrous fire wiped out the entire block of buildings. After recovering from the shock of this total loss, the citizens of Nunda went to work, and a row of brick buildings were constructed to replace the lost wooden structures. With the exception of the water tower, all the buildings shown in these photographs still stand today. (Below, courtesy of Jim Wyman.)

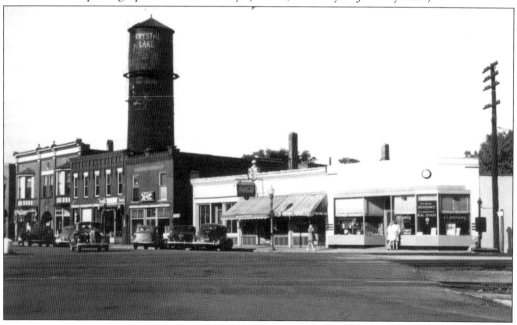

# Two

# Railroad History

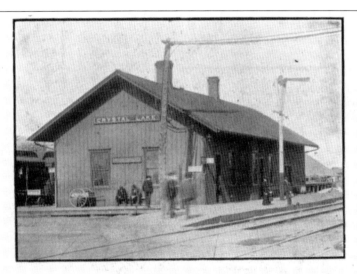

North-Western Depot, Crystal Lake, Ill.—28

**OLD DEPOT.** The Chicago and Northwestern Railroad played a vital role in the growth and development of both Nunda and Crystal Lake. Although the railroad lines actually ran through the village of Nunda, it was always known as the Crystal Lake station. No known photograph exists of the first train depot. The second depot (pictured) was built in the late 1800s and was used by both railroad personnel and passengers.

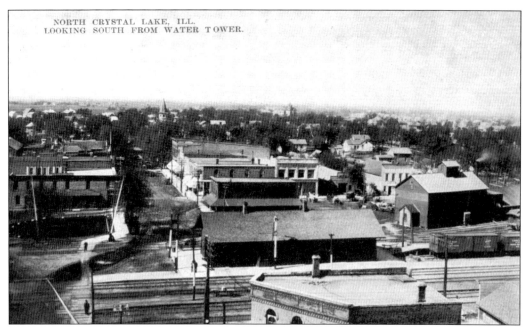

**BUSINESSES CLUSTER NEAR THE DEPOT.** These aerial photographs were taken around 1910 from the top of a nearby water tower. Businesses that were dependent on the railroad crowded around the tiny depot. Many of them catered to the rural farming community surrounding the village. There were farm implement buildings, flour and feed mills, coal storage, and lumberyards. Storage sheds held grain, hay, and even cattle waiting to be shipped by train. This was a noisy, cluttered, smelly, and possibly unsightly hub for area commerce. Other nearby commercial businesses included banks, stores, hotels, and restaurants. Some of the buildings shown in these early photographs still exist today, although many have been torn down.

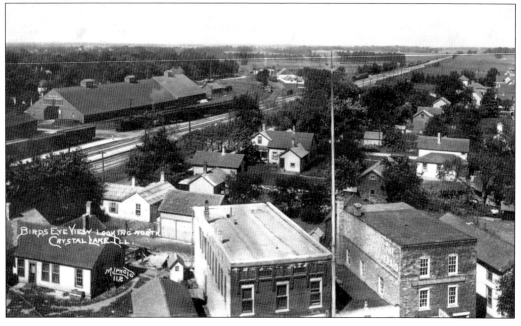

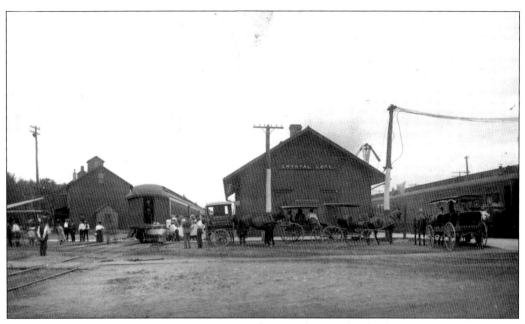

**SECOND CRYSTAL LAKE TRAIN DEPOT.** This simple wooden building served as the train depot for many years. The name "Crystal Lake" on the side of the building irked the citizens of Nunda, who in 1887 unsuccessfully petitioned to change the sign to read "Nunda." The horse-drawn carriages shown served as taxis, waiting near the depot to pick up passengers and transport them to Crystal Lake or beyond.

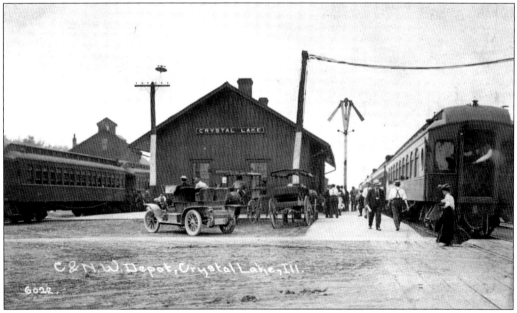

**AUTOMOBILES AND HORSES COEXIST.** Taxi service at the depot expanded to include both automobiles and horse-drawn carriages. Unlike today, the railroad tracks ran on both sides of the depot. This could explain why today's Woodstock Street was originally called South Railroad Street. The tracks on the south side of the building were used by passenger trains as well as freight trains making stops to load or unload.

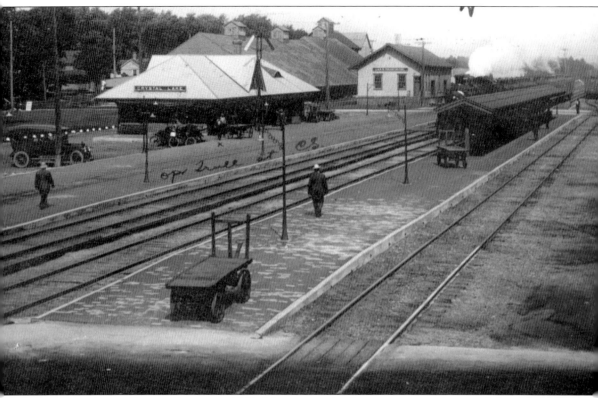

NEW TRAIN DEPOT BUILT IN 1914. The new train depot was erected west of the old depot building about mid-block between Williams Street and Grant Street. After the new train depot was complete, the old one was moved west of Grant Street and used as a freight house. Additionally, the switching points for the tracks were moved west of Grant Street. The location of the new depot and the moving of the switches was planned to help relieve congestion and dangerous conditions at the Main Street crossing. Both the new train depot (front) and old train depot (white building behind) are shown in this 1915 postcard. The freight house had its own four-foot-high platform to accommodate the loading and unloading of freight. The large structure to the left of the freight house belonged to the Wilbur Lumber Company. The long, narrow, wooden structure located between the train tracks was a passenger shelter.

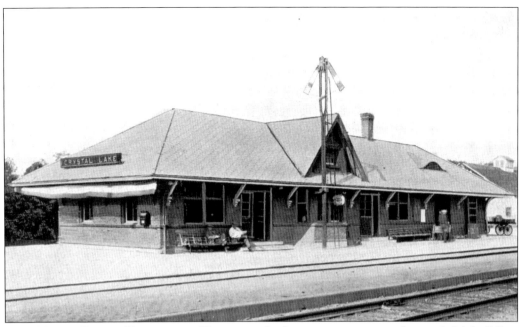

**NEW TRAIN DEPOT DESCRIBED.** The new train depot was a one-story brown brick building with a basement. The building was steam heated, with the boiler located in the basement. The roof was covered with gray asbestos shingles. The interior woodwork was red oak, quarter sawn for the panels, doors, and countertops. The interior layout included separate waiting rooms for women and men, a baggage room, an express room, and a ticket office. The floors of the waiting rooms and ticket office were constructed of hard maple, and those of the express and baggage room were cement. Both the men's and women's waiting rooms were equipped with toilets and drinking fountains.

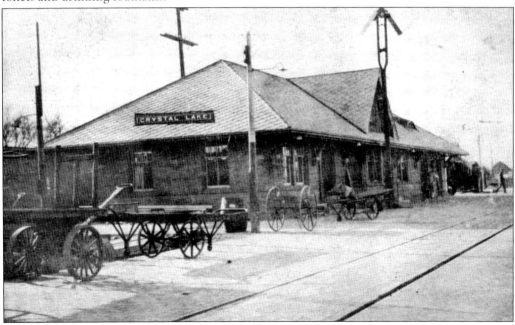

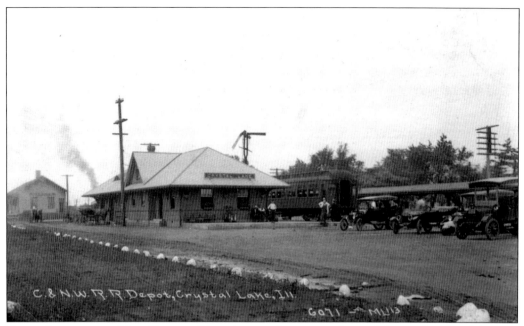

**PARK SURROUNDS NEW DEPOT.** These images show rare views of the south side of the new train depot. Changing the location of the new depot and removing the tracks on the south side of the building necessitated the removal of two large feed mills operated by Rehberg and Ehlert and Kegebein and Miller. These two firms consolidated and moved one block west near the Wilbur Lumber building. The ground formerly occupied by the feed mills was then converted into a park with driveways approaching the rear entrance of the depot building. The driveways were lined with white painted fieldstones, as shown in the above photograph. Beginning in 1915, citizens donated private funds to plant shrubs and trees to beautify the park.

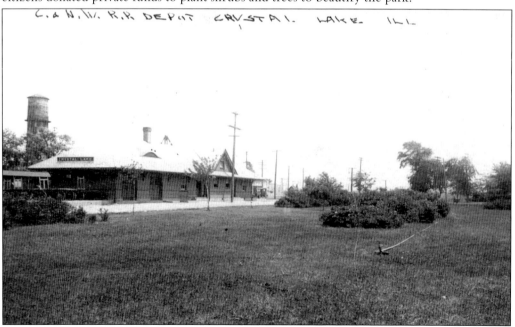

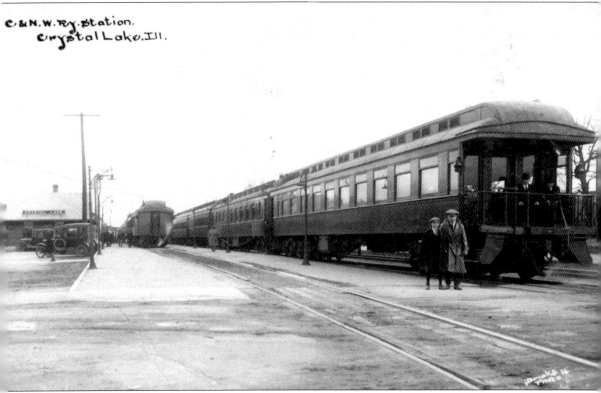

**COMMUTERS USE TRAINS.** Similar to today, many residents of Crystal Lake traveled by commuter train to their jobs in Chicago. A 1939 passenger schedule shows 17 trains leaving Crystal Lake and going to Chicago each weekday. The commute took 55 to 85 minutes, depending on the number of stops. A one-way ticket in coach cost 87¢.

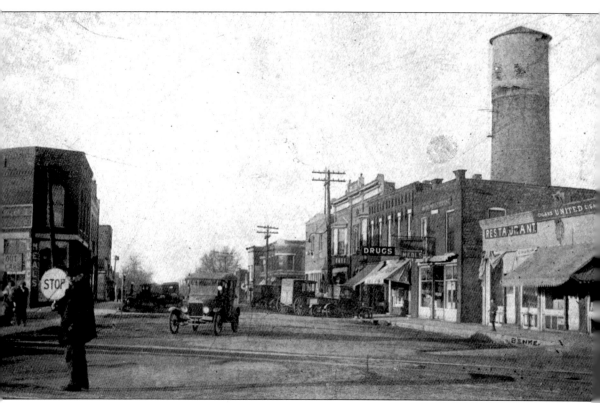

**CROSSING GUARD AT MAIN STREET.** As early as the 1880s, a gate tender and watchman was hired by the Chicago and Northwestern Railroad for the Main Street crossing. The gates were manually lowered and raised. Carl Ortman served in this capacity from 1887 to 1911, when he quit his position with the railroad, citing poor pay. At the time, he was making 8¢ per hour.

# Three
# CHURCHES AND SCHOOLS

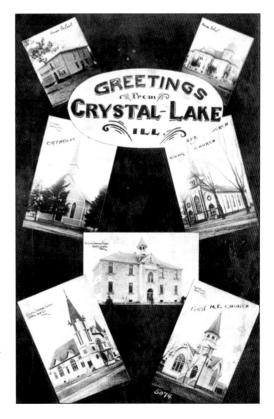

**EARLY SETTLEMENTS.** Although the two towns of Nunda and Crystal Lake had political differences, the people of both were united in their belief of the value of education and religion. Originally a 20-by-20-foot log cabin served as both a schoolhouse and church. The first schoolteacher in Crystal Lake was Hannah Beardsley. Most of the early settlers came from either Virginia or New York. They were primarily hardworking Protestant families.

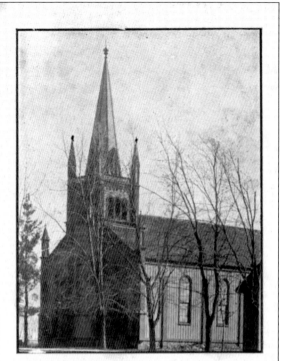

Congregational Church, Crystal Lake, Ill.—27

**CRYSTAL LAKE'S OLDEST CONTINUOUS CONGREGATION.** The First Congregational Church of Crystal Lake was organized in 1842 at the home of one of its founders, Allen Baldwin. The congregation held services at the schoolhouse until 1849 when a 26-by-40-foot frame building was erected where the current church stands on Pierson Street. Parishioners entered the building at the front of the sanctuary, facing the congregation, effectively discouraging late arrivals. Less than 20 years later, the congregation outgrew this facility and sold the building to the Methodist Episcopal Society for $400. It was moved offsite. The current church building (pictured) was erected in 1867 at a cost of $7,000. Two years later, a small chapel was built just west of the church (below). A $600 bell was donated in 1875 by Franklin W. Dike and is still in use today.

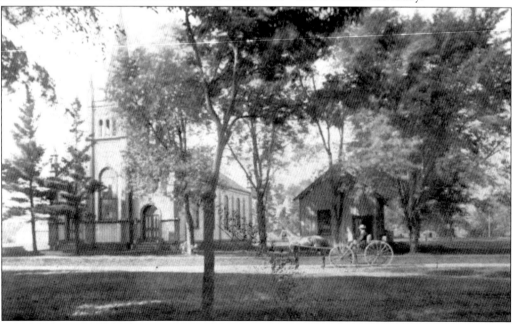

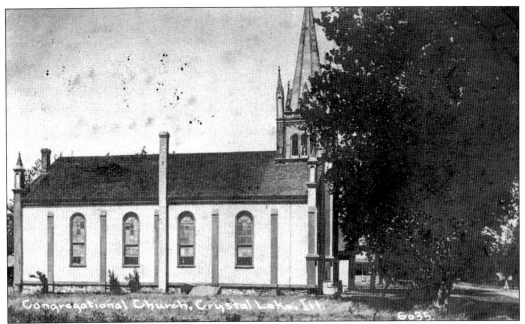

**EIGHT HISTORIC STAINED-GLASS WINDOWS.** Church records indicate the original cost of windows in 1867 was $85. The following list of surnames appears on the seven remaining stained-glass windows still on display: Gates, Pomeroy, Dike, Ford, Crow, Foster-Teckler, and Dwight. The eighth window was removed during a recent renovation.

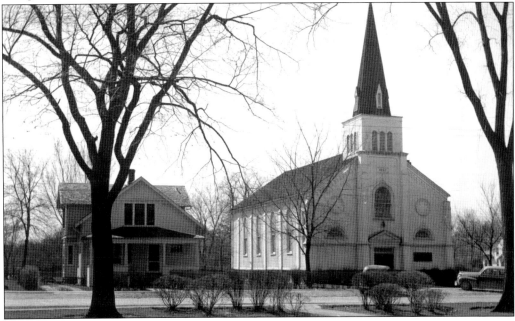

**TWENTIETH-CENTURY CHANGES FOR THE FIRST CONGREGATIONAL CHURCH.** In 1914, the chapel building was removed, a basement was built under the church sanctuary, and the two front entrances of the First Congregational Church were closed and replaced with the centered main doorway known today. The parsonage was built in 1915. During the past century, the church building has undergone numerous renovations, and the parsonage has been demolished.

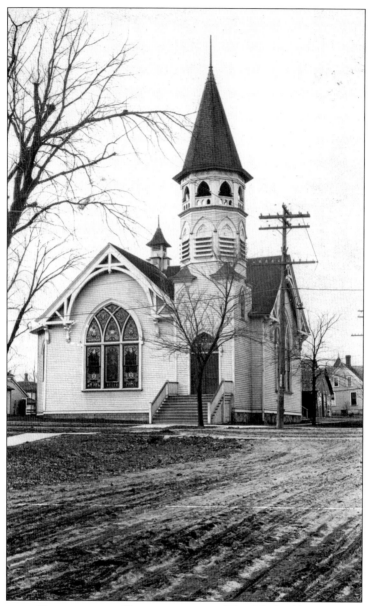

**SECOND-OLDEST CONTINUOUS CONGREGATION.** The Methodist Episcopal Church was organized at Crystal Lake in 1846. Services were held in the schoolhouse until 1858. At that time, the congregation built a frame house of worship on Virginia Street in the village of Crystal Lake. By the mid-1860s, when the village of Nunda had grown to some size, it was found that nearly half of the Methodist Episcopal congregation lived there. Those members living in Nunda wanted to sell the Crystal Lake church to build a new one in Nunda. The members living in Crystal Lake did not agree. And so, for a time, the congregation was split. The Nunda faction worshipped in a hall in Nunda and engaged the services of the minister half the time. In 1867, the Nunda congregation purchased the old Congregational church building for $400 and moved it to Nunda. Eventually the Crystal Lake members joined the Nunda group. The reunited Methodist Episcopal congregation continued to grow. During the summer of 1873, a new church was erected.

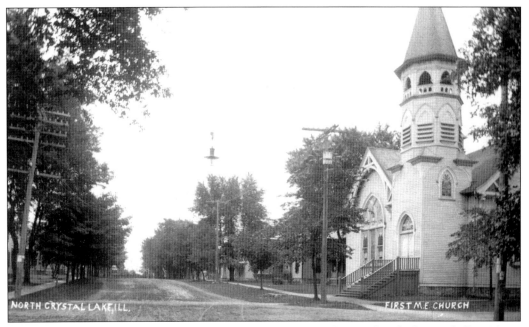

METHODIST EPISCOPAL CHURCH IN DOWNTOWN NUNDA. Centered in the heart of a flourishing business district, the Methodist Episcopal church stood at the southwest corner of Williams Street and Brink Street for 80 years. These facilities were remodeled extensively in 1898 and again in 1920 to meet the needs of the growing congregation. The church parsonage stood directly across the street on the east side of Williams Street.

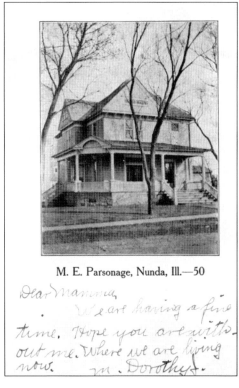

M. E. Parsonage, Nunda, Ill.—50

CHURCH AND PARSONAGE LEAVE DOWNTOWN. In the mid-1950s, the congregation made plans for a move away from the business district, and six acres were purchased on West Crystal Lake Avenue. A new church was built on that site. The old church was demolished to make way for a Jewel Grocery Store. The parsonage was moved to Paddock Street and is a private residence today.

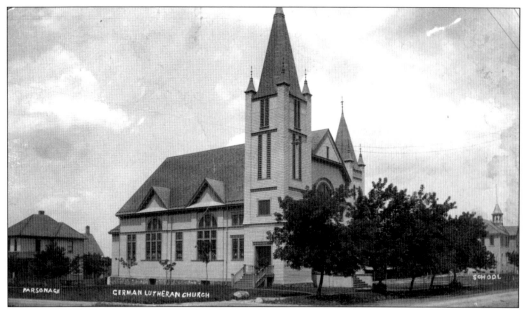

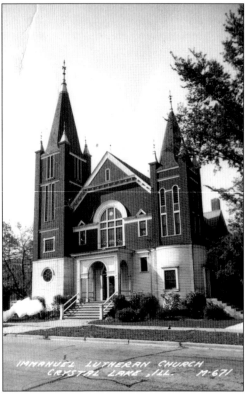

**IMMANUEL LUTHERAN CHURCH.** In 1870, the German Lutheran congregation was organized as Immanuel Lutheran Church. Parishioners assembled in private homes or rented buildings for church services. Education was given first priority, so a schoolhouse was built in 1875. Two years later, the congregation purchased the old Methodist church for $400 and moved it to a property on McHenry Avenue. The congregation continued to grow. In 1895, a new church (pictured) was built at a cost of $6,400. The church has had numerous additions and facade alterations. Services were regularly held in German until 1915, when they were conducted in English and German. In 1905 and 1906, respectively, a new school and parsonage were built.

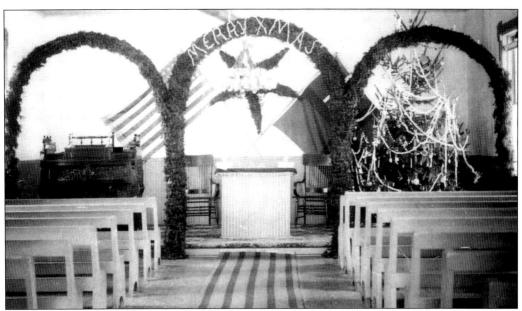

SWEDISH MISSION CHURCH. There was a large Swedish community within the twin towns of Nunda and Crystal Lake that was commonly referred to as Swedenburg. It was centered on the Swedish Mission Church, which was located near Crystal Lake Avenue and Lincoln Parkway. Built in 1893, the first church was a small, simple frame structure. Services were held in Swedish. The photograph above shows the interior decorated for Christmas in 1910. Extensive renovations and additions increased the size, shape, and look of the first church. In 1936, the congregation voted to change its name to the Evangelical Mission Church. In later years, it became affiliated with the Evangelical Free Church of America. In 1993, the congregation built a larger church farther east on Crystal Lake Avenue, and the old church was sold to the Salvation Army. (Above, courtesy of Debby Schulz.)

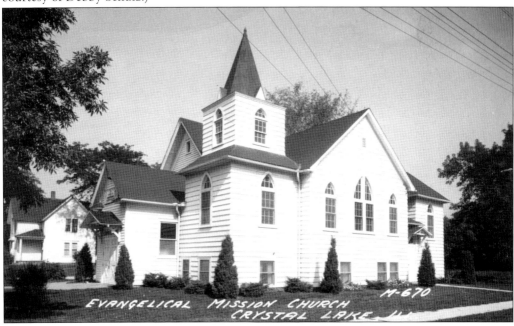

**SWEDISH LUTHERANS ORGANIZE.** Bethany Lutheran Church was first known as the Swedish Evangelical Lutheran Bethany Church. The first church building was erected in 1925 at the corner of Crystal Lake Avenue and Elmhurst Street. The total actual cost of this building was $24,000. To reduce costs, the members dug the foundation for the building by hand. This building was later demolished, and the current church was built in 1978. In 1931, a parsonage was built on the lot next to the church. This was a Sears catalog home (Strathmore model). Almost all the labor and some of the materials were donated by members and others. This home was later moved to South McHenry Avenue where it is used today as a private residence.

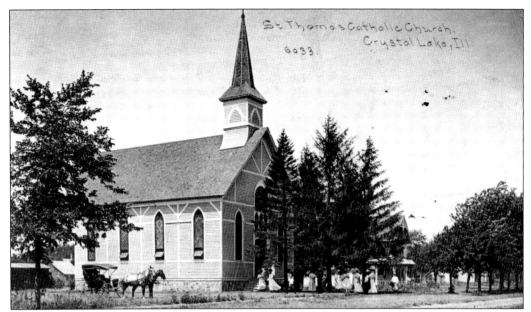

**CATHOLIC MISSION CHURCH.** As early as 1856, a Catholic Mission Church was organized in Crystal Lake. The tiny congregation met to worship in a log cabin situated in the middle of Mount Thabor Cemetery. In 1881, land on Park Street (now Pierson Street) was purchased, and a new frame church was built. This building served the congregation until 1925. It still stands and has been converted to a private residence.

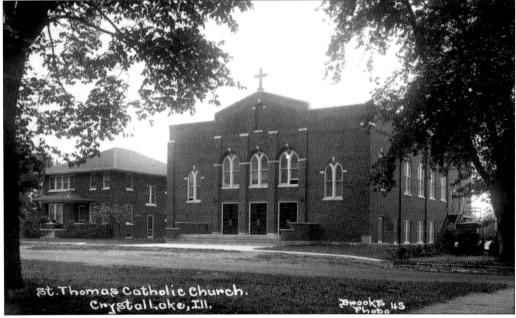

**ST. THOMAS CHURCH.** In 1922, Fr. Edwin A. McCormick was appointed the permanent pastor for St. Thomas Church. Libby Duffy Reynolds, a parishioner, donated four lots for a new church, school, and rectory about two blocks east of the old church. This new church building was dedicated in 1925. It served the congregation until 1968 when a larger church was built on Route 176.

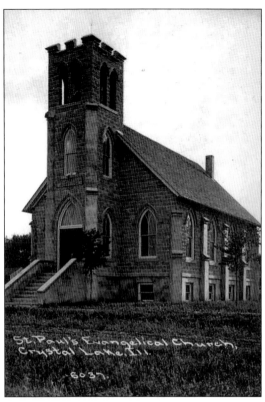

**ST. PAUL'S CHURCH.** St. Paul's was started in 1896 as a mission venture for the Evangelical and Reformed Church. By 1907, the congregation bought three lots on Ellsworth Street for $850. In 1910, this church building was erected at the corner of Ellsworth and Sherman Streets. St. Paul's sold this building in 1960 and moved to Woodstock Street. It is currently owned by the Masonic Lodge.

**CHURCH OF CHRIST.** Church of Christ (also called the Disciple Church) was organized in 1874 and stood north of the railroad tracks in Nunda. In 1926, the building was purchased by the Independent Order of Odd Fellows (IOOF) and moved to Woodstock Street to be remodeled into a lodge home. The building was destroyed by fire in 1932.

**SCHOOLS DISTRICTS MERGE TO BUILD UNION SCHOOL.** In the early 1880s, the village of Nunda had a small, wood-frame school on the north side of Terra Cotta Avenue (Route 176) at the north end of Main Street. The village of Crystal Lake had a two-story brick school at the corner of Park Street (now Pierson Street) and King Street. Both schools were beyond capacity. In a rare instance of cooperation, the two towns merged their school districts and built the Union School in 1883 at a cost of $15,000. The two-story Italianate-style brick building was located at the corner of Paddock Street and McHenry Avenue. There were six classrooms in the school, educating students from first grade through high school. In 1886, two students made up the first high school graduating class.

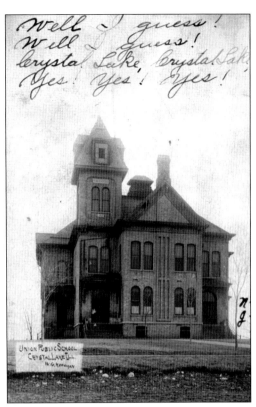

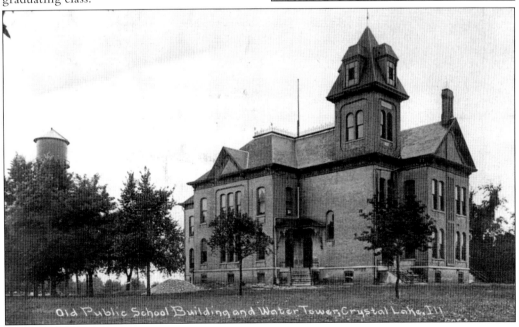

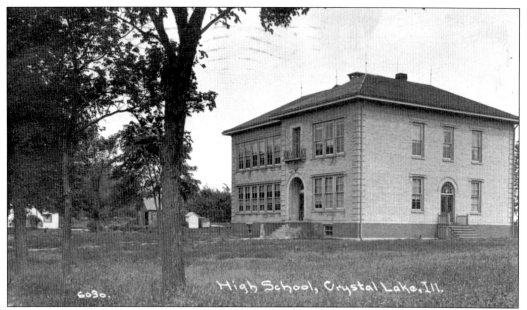

**HIGH SCHOOL BUILDING ON PADDOCK STREET.** When Union School was built, it was intended for an enrollment of 240 students. By 1900, it was bursting at the seams, and the need for another school was apparent. In 1906, a high school building was constructed on an adjoining lot. The elementary classes stayed in the Union School building, and the older classes moved next door to the new high school.

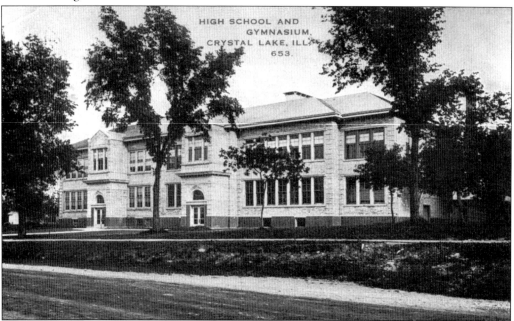

**HIGH SCHOOL ADDITION.** An unexpected cash windfall of $35,000 from the Alfred M. Barber estate funded the addition of a gymnasium, four classrooms, and an assembly hall in 1914. The high school addition was designed by Crystal Lake resident William Chandler Peterson, who was a student of architecture at the University of Illinois. Peterson was killed in action during World War I. American Legion Post No. 171 was named in his honor.

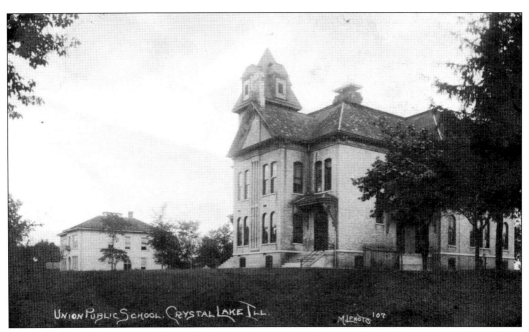

**CONNECTED BUILDINGS.** These photographs give a perspective of how the two school buildings sat in relation to each other. They were connected by several underground concrete tunnels, used primarily by maintenance workers and staff. In 1914, a new heating plant was added to service both the elementary school and high school. The old outside toilets were torn down in 1915, and indoor bathrooms were installed. The high school building was converted to a junior high school after Crystal Lake Community High School was built in 1924. The 1883 Union School building was demolished in 1949. The 1906 building was torn down in 1978. Today Husmann Elementary School stands on the site.

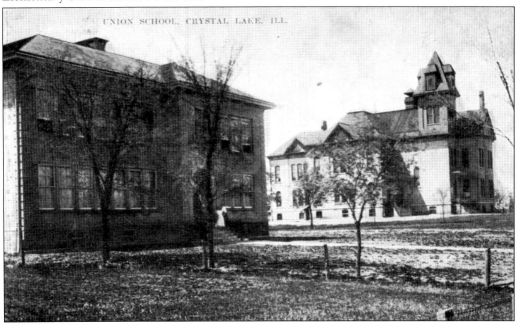

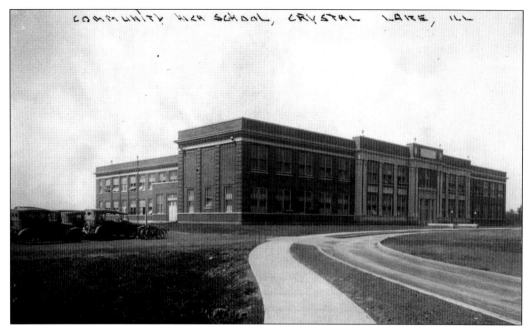

**CRYSTAL LAKE COMMUNITY HIGH SCHOOL.** In 1921, the Crystal Lake community authorized the purchase of property on Franklin Street for the construction of a new high school. Construction costs for the new building exceeded $300,000. The school was called Crystal Lake Community High School. The first class to graduate from this building was the class of 1924. D. M. Ewing was the first principal. In 1928, the athletic teams began to use the nickname Tigers, which is still in use today. Numerous additions have been built onto the original structure. Due to the increase in population, two additional high schools have since been built in Crystal Lake.

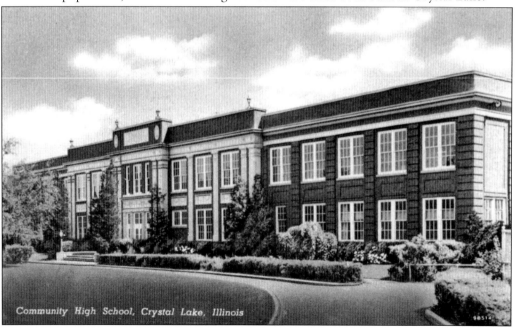

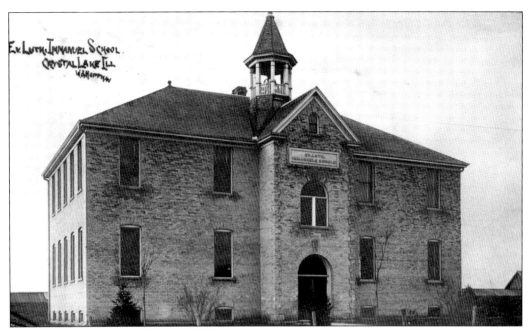

IMMANUEL LUTHERAN SCHOOL. In 1905, the student enrollment of the German Lutheran School exceeded the original building's capacity. Over 150 pupils were crowded into two classrooms. A new brick schoolhouse was built in 1906 at a cost of $9,400. Numerous additions have been made to the structure during the past 100 years.

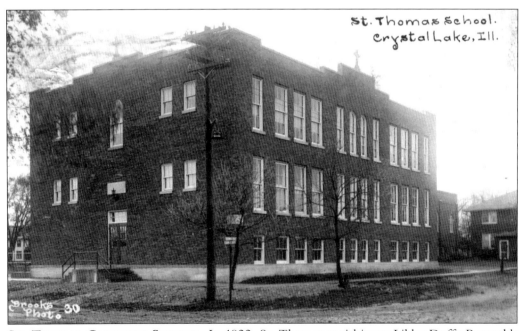

ST. THOMAS CATHOLIC SCHOOL. In 1922, St. Thomas parishioner Libby Duffy Reynolds donated four lots on Pierson Street to be used for a new rectory, church, and school, which were built in that order. St. Thomas Catholic School opened its doors in September 1927, with an enrollment of 105 students. The original school is still being used today.

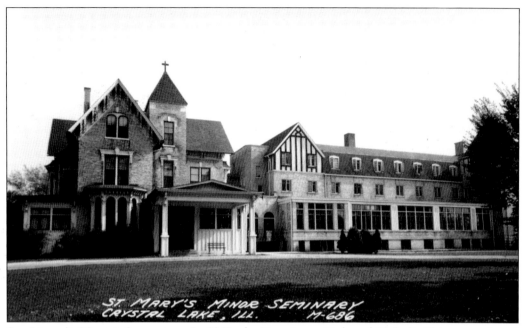

**ST. MARY'S MINOR SEMINARY.** In 1945, the Franciscan Order of Catholic Priests purchased the old Dole mansion/country club property (see chapter 5) and converted it to a high school for boys. Young men wishing to pursue priesthood as an occupation or simply desiring a strong Catholic education enrolled as students. The first-floor parlors of the Dole mansion were used as a chapel (below) and the mansion bedrooms were occupied by the priests. The country club addition was used for classrooms, a dining room, a library, and dormitory rooms. Initial enrollment in 1945 was 30 students. The peak enrollment of 75 students was hit in 1957. Thereafter, a steady decline of students forced St. Mary's to close its doors in 1970.

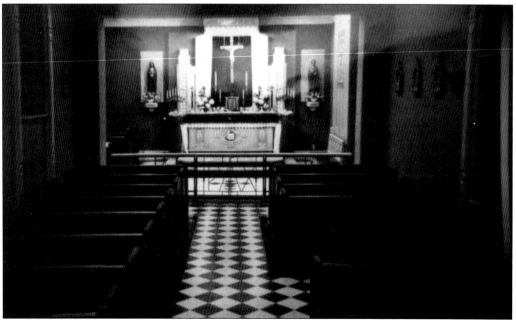

# Four

# Private Lakefront Resorts

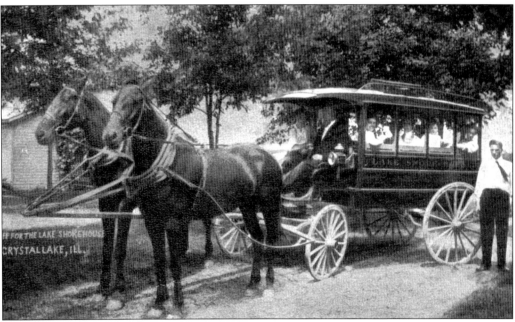

SUMMER HOME. From the late 1800s to early 1900s, Crystal Lake was a resort community, attracting tourists from nearby Chicago as well as far-away places. Large and small summer resort hotels lined primarily the north shore of Crystal Lake. The largest, most popular of these hotels were the Lake Shore House and Leonard Hotel. Guests arrived by train and were transported to the lake by horse-drawn carriages.

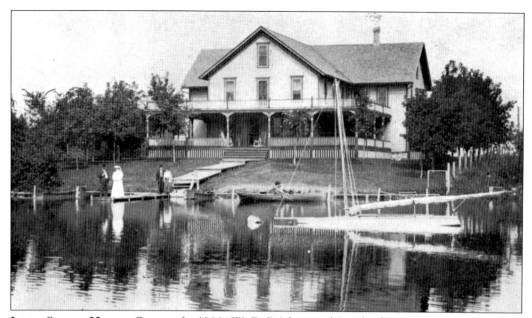

LAKE SHORE HOUSE OPENS. In 1900, W. E. Prickett and Son built a $5,000 resort hotel on the north shore of Crystal Lake. A contest was held to name it. Jane Dike won the contest with her entry, Lake Shore House. The resort was large for the time, having 23 guest rooms, which accommodated up to 60 people. Rates in 1900 were $2 a day or $10 a week.

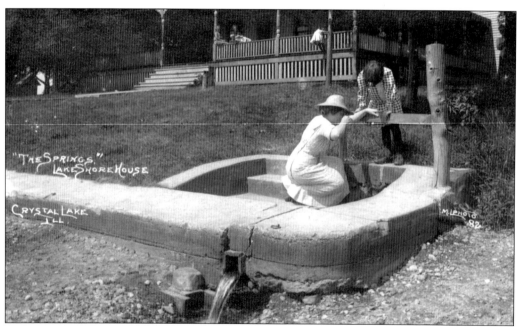

PRICKETT'S SPRING. The spring at Prickett's Lake Shore House was known for its medicinal qualities. In 1906, it was reported that an analysis of the water by the laboratories of the University of Illinois indicated it had "valuable curative properties, especially beneficial to those suffering from kidney and liver complaints." Visitors and residents of Crystal Lake came to Prickett's to use and enjoy water from the spring.

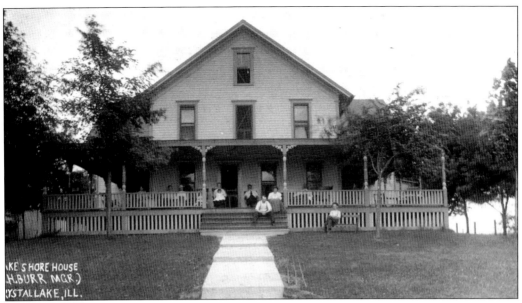

**NEW OWNERS FOR LAKE SHORE HOUSE.** In 1908, W. E. Prickett and Son sold the Lake Shore House for $11,400 (fully furnished) to Gertrude Wiltberger, a widow. Wiltberger hired Robert Burr to manage the hotel. Together they continued to maintain the high level of excellent service associated with the Lake Shore House. The 1908 season opened in grand fashion, with 100 guests enjoying the hospitality and sumptuous turkey dinner provided. Music played throughout the day, and the hotel was decorated throughout with pink and white carnations. Burr and Wiltberger must have made a good team, as they married each other in 1910.

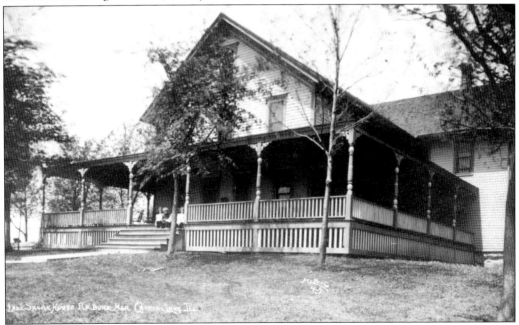

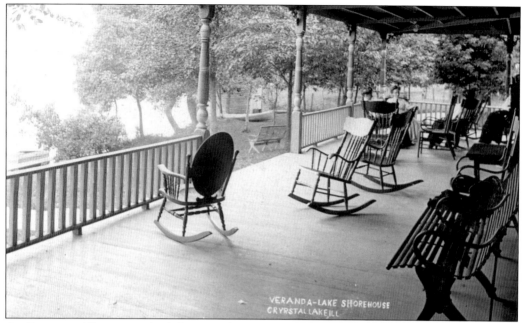

**AN INVITING VERANDA.** A 12-foot wooden veranda (porch) surrounded three sides of the Lake Shore House. The veranda featured a safety railing and decorative, bracketed posts. Numerous benches and rocking chairs were scattered throughout. No doubt the veranda was a favorite place for guests to sit, relax, and view Crystal Lake.

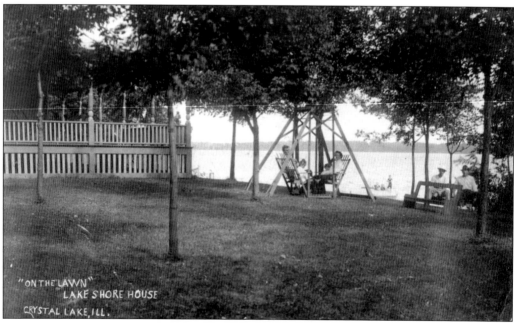

**LAWN FOR LEISURE ACTIVITIES.** The front of the hotel was set 30 feet back from the water's edge. The front lawn provided additional leisure opportunities for resort guests. Pleasant breezes and fresh air were certain to draw guests to the lawn swings and benches. Walking paths around the property led to beautifully landscaped gardens.

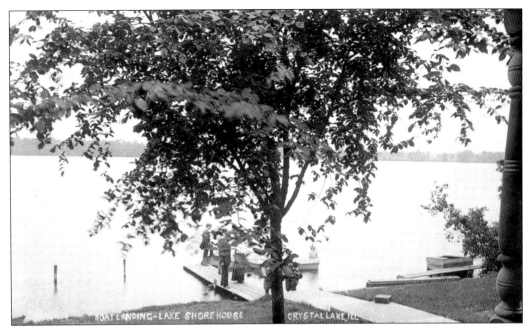

**OWNERS CHANGE AGAIN.** By 1920, the Lake Shore House was owned by Mr. and Mrs. George Brawner and Mr. and Mrs. Eli Corr. The new owners completely repainted the interior and exterior of the hotel, four new garages were built, and a laundry was installed with an electric washing machine—a very modern convenience. The south part of the veranda was screened in for the comfort of the guests. Six new boats were built for the use of guests, and the hotel became a favorite for fishing parties. Mrs. Corr continued to run the Lake Shore House for the next two decades. By the mid-20th century, the resort business in Crystal Lake dwindled, and the Lake Shore House soon became more of a boardinghouse. It was destroyed by fire in 1982.

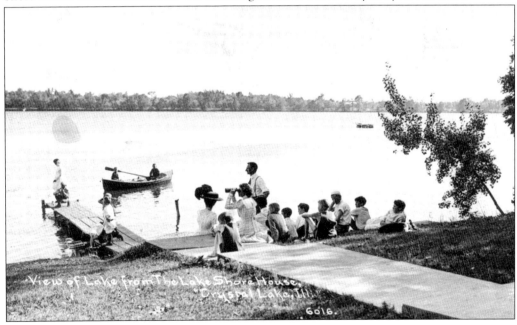

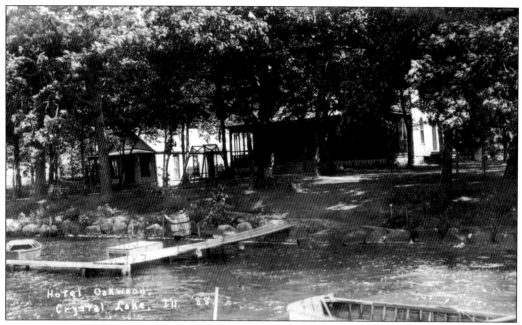

**OLD LEONARD HOTEL.** By 1885, Thomas Leonard owned a large, two-story home on the north shore of Crystal Lake. The home had a long porch that ran the length of the front of the house. The house was ideal for Leonard's large family, but he had another idea about using the house as a summer resort. Near the dawn of the 20th century, the home was opened up to the public and was known as the Leonard Hotel. In 1908, the Leonard family moved on and purchased another hotel property near the northeast corner of the lake, calling it the New Leonard Hotel. By 1920, Robert and Gertrude Burr, recent owners of the Lake Shore House, assumed management of the Old Leonard Hotel, renaming it Hotel Oakwood. The building is currently a private residence.

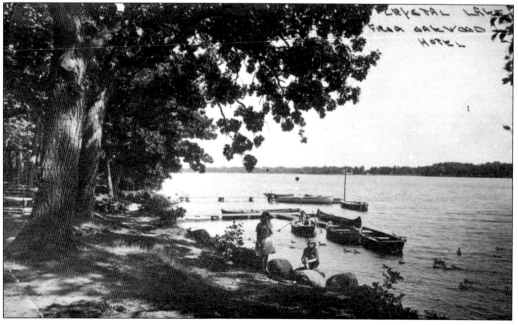

**THE BYFORD MANSION AND ESTATE.** Dr. Henry Byford was a prominent and wealthy gynecologist from Chicago. He wrote several books about the care of women during childbirth. In 1892, he purchased eight acres of lakefront property from James Crow. A year later, Byford spent $15,000 to build a beautiful three-story Victorian mansion. This 25-room house was the Byford family summer home.

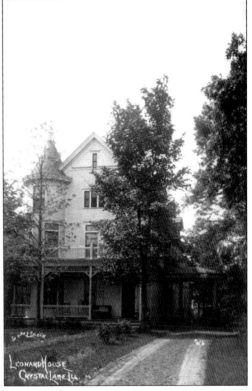

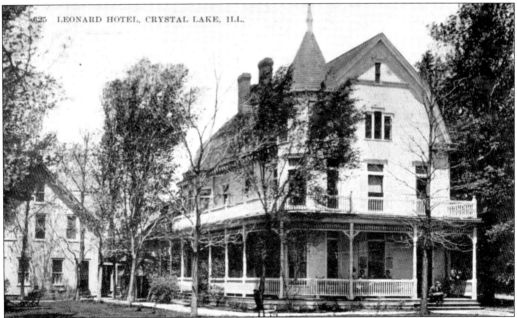

**THE NEW LEONARD HOTEL.** In 1908, Leonard's youngest son, Patrick, purchased the Byford mansion and estate with the intent to open up the New Leonard Hotel. However, his father, the family patriarch, died within a few months of this purchase. With the help of his older sister Sarah, Patrick opened the hotel and carried forward the family's reputation of quality and service.

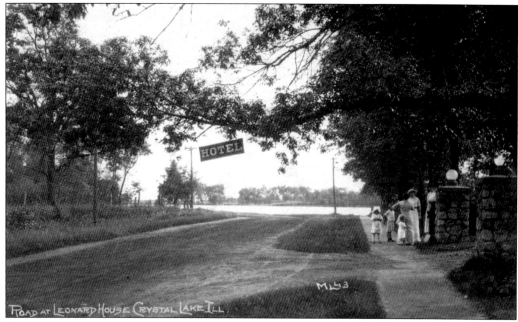

**HOTEL OPEN FOR BUSINESS.** Today's Lake Shore Drive was once known as West Street. It ran between Virginia Street and the lakefront. The New Leonard Hotel was accessed from West Street. The hotel sign was hung from a tree, directing visitors to the New Leonard Hotel, which was also known as the Leonard House Hotel. The hotel drive entrance was flanked with elaborate, lighted stone pillars. It was located approximately where today's Leonard Parkway meets Lake Shore Drive. The driveway ran along the northeast side of the hotel. The photograph below shows a glimpse of the lake to the left of the building.

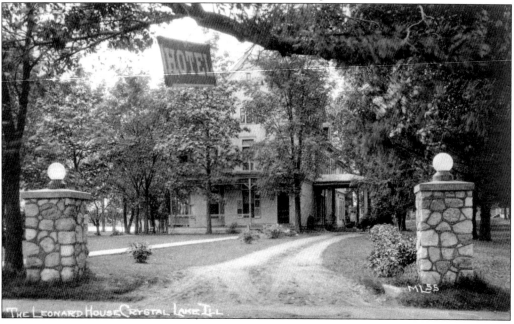

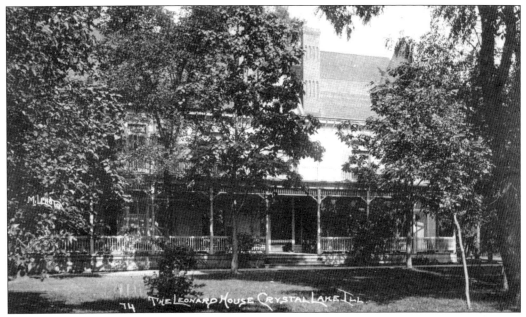

**LARGE AND POPULAR.** The three-story Leonard House Hotel was 30 feet wide and 80 feet long, large enough to accommodate nearly 100 guests. Pat Leonard had a reputation as a genial innkeeper, and his hotel became the most popular of all resort hotels on Crystal Lake. He enjoyed hunting and fishing and often provided fresh game and fish for his guests' dinner.

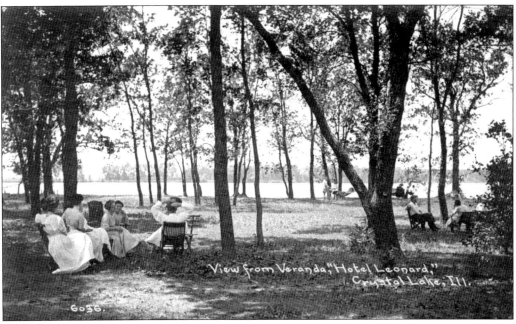

**HOTEL VERANDA.** A spacious veranda ran the entire length of the building facing Crystal Lake. Numerous chairs and benches were scattered across the veranda and in the yard to accommodate guests, as they were able to relax and enjoy the lake breezes. The view from the veranda most certainly afforded guests a spectacular show of the setting sun each evening when it reflected off the lake.

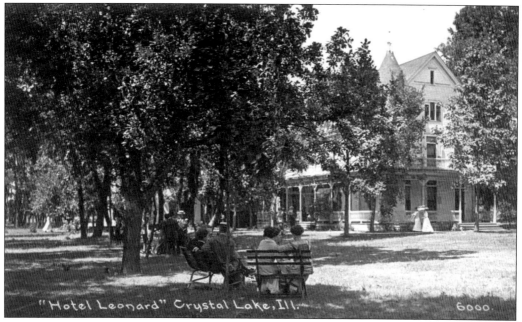

**RELAXATION AND LEISURE.** The large, manicured lawn on the south and east sides of the hotel provided plenty of room for leisure activities such as croquet. The gardens and walking paths afforded Leonard's guests an opportunity to enjoy the scenic lakefront views. Tables and chairs were set up outside in the lawn and on the veranda. For those looking for a bit more activity, Pat Leonard often took small groups on hunting and fishing excursions. In the evening, the Leonard Hotel hosted concerts and hired entertainers to keep the guests amused. Leonard's sister Sarah estimated that during the 1909 season, over 1,500 guests registered at the hotel.

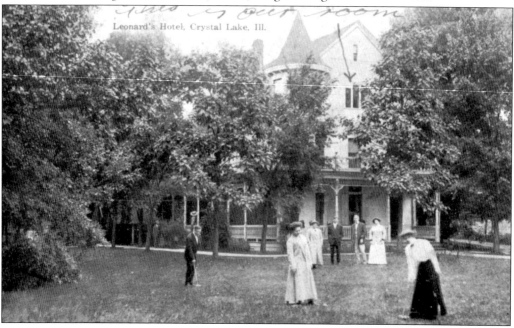

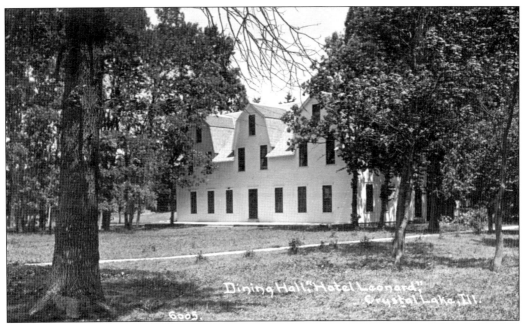

**TRIO OF COTTAGES.** Business was so good that Leonard built a trio of attached cottages to accommodate additional guests. The ground-level floor of the cottages was used as a large dining hall. The second and third floors had guest rooms. Rooms in the main hotel (Byford mansion) and in the three cottages could be rented for a day, a week, a month, or the entire summer season. The cottages were intended for summer use only, as there was no central heating system. In later years, the cottages were separated and sold as individual houses. The trio still stands today at 621, 623, and 627 Leonard Parkway as private residences. Their distinctive gambrel rooflines are still evident on both the street and lakefront sides.

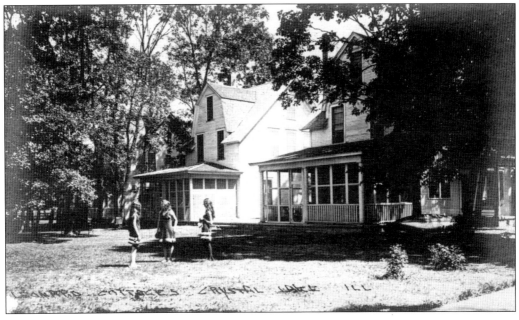

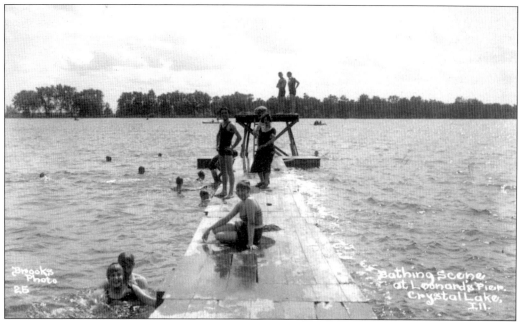

**IMPROVEMENTS AT THE LAKE.** In addition to the trio of cottages, Pat Leonard made several other improvements to his hotel property. An extended pier with a high platform was built to accommodate swimmers. Two boathouses were built at the water's edge, and rowboats and sailboats were provided for guests to use. An outdoor canteen provided a place for guests to get refreshments without traipsing back up to the main building. The Leonard Hotel enjoyed a fine reputation for less than a decade. In November 1917, fire destroyed the beautiful Byford mansion. All occupants were able to escape the building, and a few household furnishings were salvaged. After the fire, Leonard decided to retire from the hotel business. He subdivided his eight-acre estate and created a subdivision called Leonard Manor.

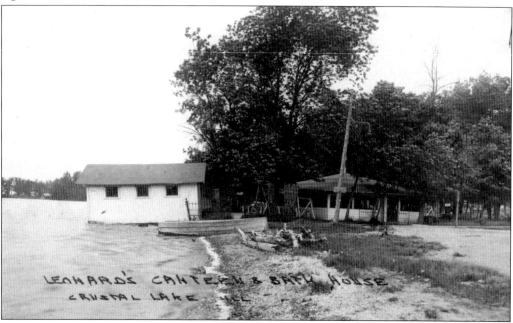

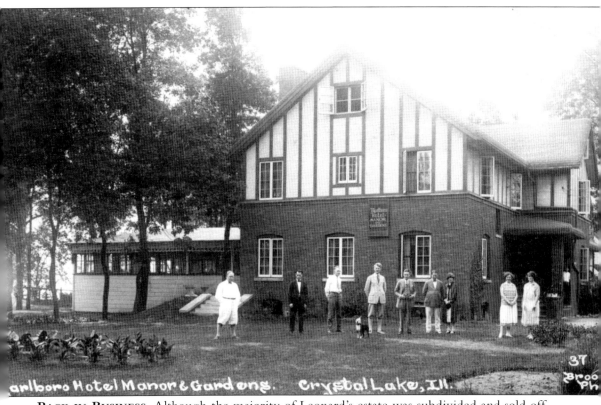

**BACK IN BUSINESS.** Although the majority of Leonard's estate was subdivided and sold off, he retained ownership of three lakefront lots. He built a large brick house near the site of the original Byford mansion. Leonard, his wife, Helen, and son Ralph lived in the brick house for several years.

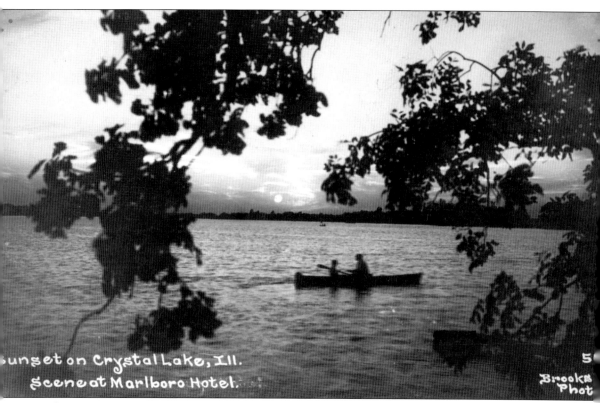

**SCENE AT MARLBORO HOTEL.** In the late 1920s, Pat Leonard reentered the resort trade. He remodeled and opened his house to the public, calling his resort the Marlboro Hotel Manor and Gardens. He died in 1930. His son Ralph stayed on to raise the next generation of Leonards at the brick house, once known as the Marlboro Hotel. The former hotel is currently a private residence at 615 Leonard Parkway.

# Five

# Dole Mansion and Crystal Lake Country Club

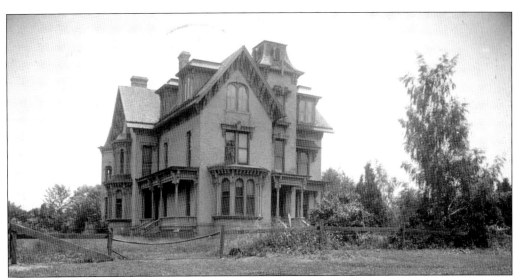

**Great Estate.** Perhaps the most historically significant structure in Crystal Lake, the Dole mansion was built about 1865 by Charles S. Dole. Dole made his fortune in the wheat and grain industry, being an early member of the Chicago Board of Trade. This elegant Italianate-style home features parquet floors, black walnut woodwork, and marble fireplaces. Construction costs exceeded $100,000, an enormous amount of money in those days.

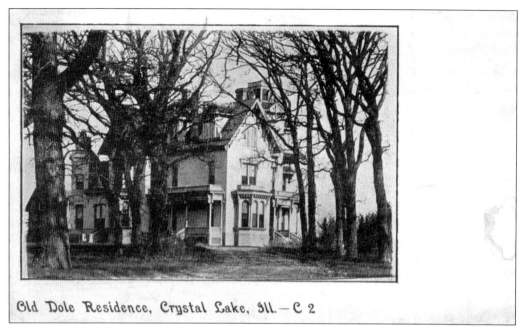

Old Dole Residence, Crystal Lake, Ill. — C 2

**THE DOLE MANSION.** The Dole mansion property has been used as a private residence, ice company business office, country club, seminary, church office, preschool/day care, and an arts park. Through the years, the mansion has been neglected, renovated, and neglected again. Despite these extreme cycles of stewardship, many of the historic architectural elements have remained intact.

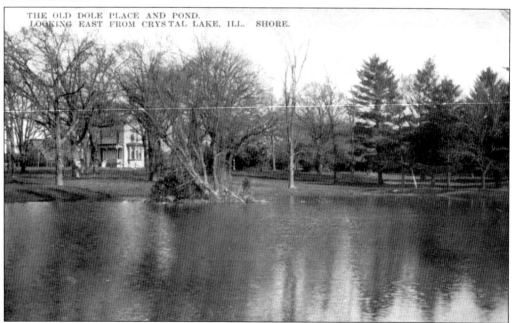

THE OLD DOLE PLACE AND POND. LOOKING EAST FROM CRYSTAL LAKE, ILL. SHORE.

**THE DOLE PROPERTY.** The original 1,000 acres of surrounding land once owned by Charles S. Dole has now been reduced to 12 acres. Dole owned the area known today as Main Beach. Beginning in 1879, he set the precedent for public beach use by allowing residents to use his property for picnics, swimming, fishing, and boating. He even provided the boats.

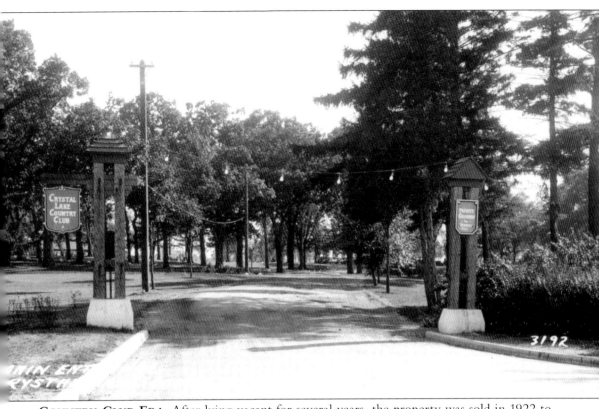

COUNTRY CLUB ERA. After lying vacant for several years, the property was sold in 1922 to the Lake Development Company. The transaction involved nearly $500,000 and was one of the largest real estate deals handled in the area. Eliza "Lou" Ringling was one of the principal investors and vice president of the Lake Development Company. She was the widow of the oldest Ringling brother of circus fame. Under her guidance, the Dole mansion was completely renovated and became home to the Crystal Lake Country Club. An 18-hole golf course was built, with plans for a second course underway. Excess property not needed by the country club was later subdivided into lots and sold, thus creating the Country Club Additions Subdivision of Crystal Lake.

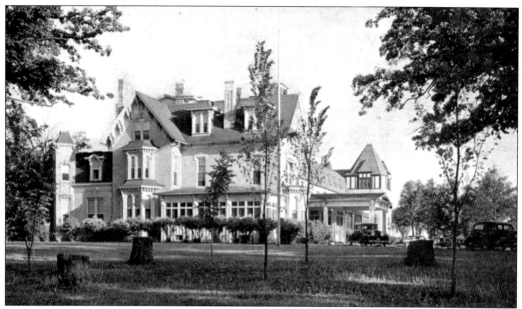

**MANSION USED AS CLUBHOUSE.** Initially the rejuvenated Dole mansion provided space for club members to meet, greet, and eat. After only three years, membership in the Crystal Lake Country Club exceeded 200, and the Dole mansion became too small to accommodate the membership. The decision was made to hire architect Frederick Stanton to design and build an addition to the mansion.

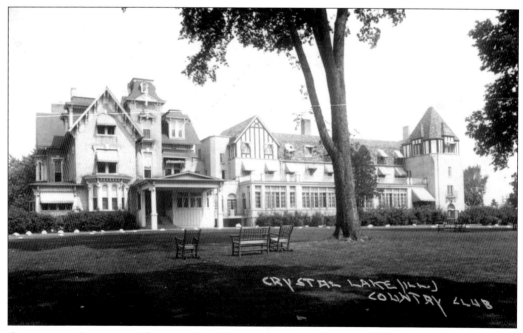

**CLUBHOUSE ADDITION.** The groundbreaking ceremony for the new addition was held on March 8, 1925. Construction took about 15 months. Stanton described the addition as "somewhat along the lines of Old English," and it was kept subdued so as not to complete with the architecture of the Dole mansion.

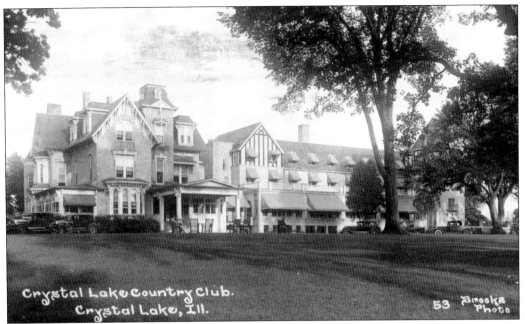

**BUILDING ADDITION FACILITIES DESCRIBED.** The addition had three floors and a basement. It included 44 bedrooms, a dining salon, a ballroom, a sun parlor, a reception room, locker rooms, and a large outdoor terrace. The entrance of the new building was through the old building, with the mansion's dining room used as a reception room.

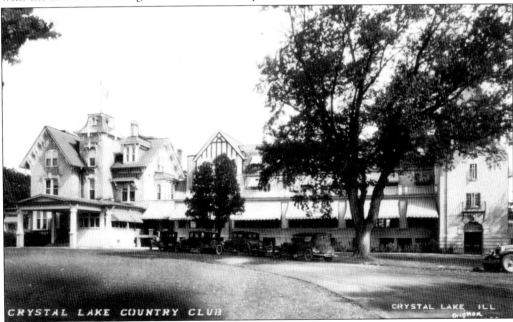

**CLUB KEEPS GROWING.** By February 1926, an aggressive membership drive brought the club's total up to 479 members. Memberships were selling for $500 for the first 500 members. After 500 members joined the club, the price increased to $1,000. Although local residents also joined, many members of the Crystal Lake Country Club were influential businessmen from Chicago.

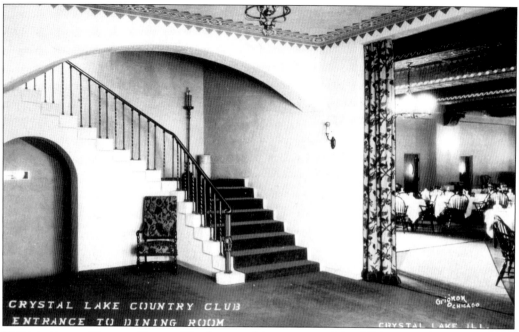

**ENTRANCE TO DINING ROOM.** The layout of the country club addition was slightly different than it is today. The entrance shown in this photograph opens directly into the dining room. The arched doorway on the left led to a passageway under the stairs that connected the Dole mansion to the country club addition.

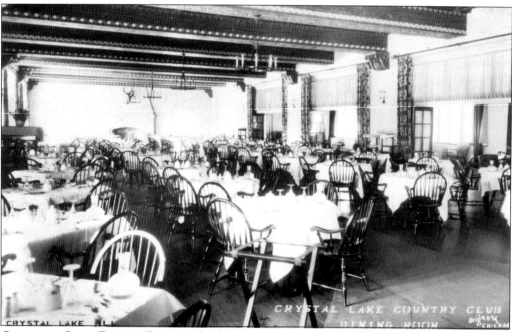

**COUNTRY CLUB DINING ROOM.** The dining room was 38 feet wide by 136 feet long, which allowed a seating capacity of 300. The enclosed porch along the front of the building was connected to the dining room by large French doors. The two doorways flanking the fireplace at the far south end of the room led outside to a 60-foot-square dancing terrace.

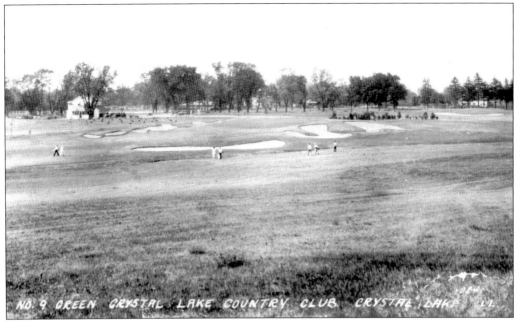

**GOLF IS KING.** The most popular leisure activity offered at the Crystal Lake Country Club has always been golf. The first nine holes of the first golf course were ready for play in July 1924. "The greens are large and of the most modern type being rolling in design and with scientifically placed bunkers," was a description of the course.

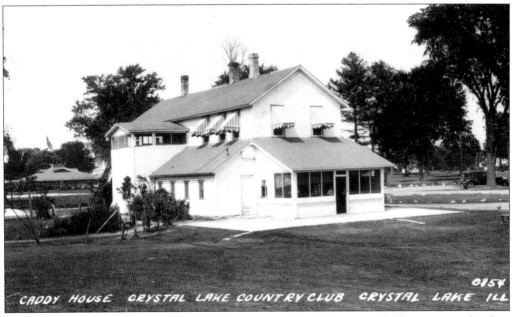

**CADDY HOUSE.** The caddy house was located south of the main clubhouse near the first 18-hole golf course. A second 18-hole course opened up in 1929. Scottish-born Forbes Leith was the country club's golf professional and superintendent for 16 years. The Leith family lived on the second floor of the caddy house.

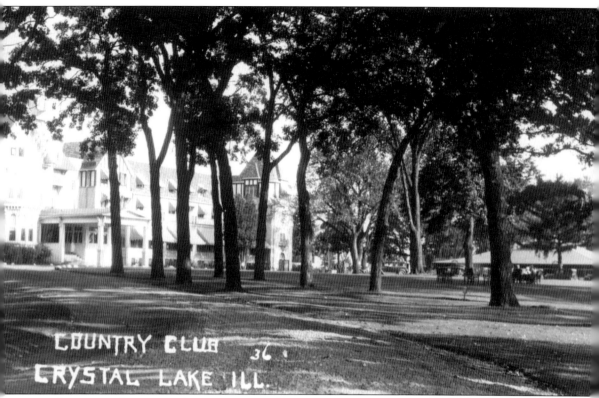

**OUTDOOR AMENITIES DESCRIBED.** In addition to golf, other outdoor amenities at the country club included a boating dock, a swimming beach, riding stables, and three tennis courts. The country club maintained an 80-acre hunting preserve with blinds, rice fields, and various decoys. The club was known for its duck hunting in the fall, as well as rabbits, pheasants, and prairie chickens. An outdoor dance pavilion is shown tucked back in the trees at the right side of this postcard. Landscaped lawns with walking paths and benches with views of Crystal Lake also enhanced the outdoor beauty of the property.

# Six
# LAKEFRONT, PARKS, AND RECREATION

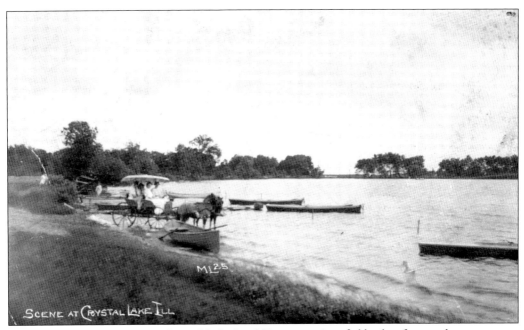

**CRYSTAL CLEAR WATERS.** Crystal Lake is a 233-acre spring-fed body of water that spans over 1.25 miles in length across both Algonquin and Grafton Townships. The lake has a maximum depth of 40 feet. In its earliest days, Crystal Lake provided a clean, clear drinking water source to residents (both animals and humans) of the nearby village.

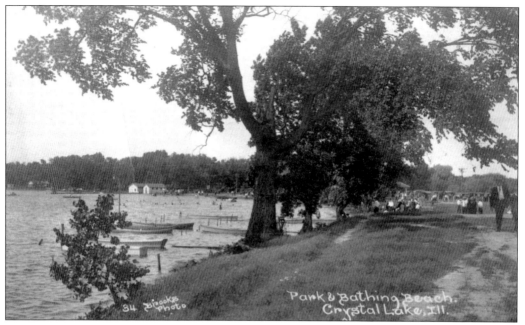

PUBLIC OWNERSHIP OF MAIN BEACH. The Crystal Lake Park District was established in 1921 with the initial purpose to obtain public ownership of the Main Beach property and forever secure public access to the lake and beach. The newly formed park district board, made up of president Ben Raue and commissioners P. F. Rosenthal, Frank Schramm, John C. Flotow, and Dennis Kelly, unsuccessfully negotiated with the Consumer Ice Company for this land and then instituted condemnation proceedings. In 1923, the park district won its lawsuit and was awarded 1,500 feet of lakefront and approximately 22 acres of land for the sum of $19,250. Shortly after taking ownership, a simple wood structure was erected to provide shelter for visitors to the beach.

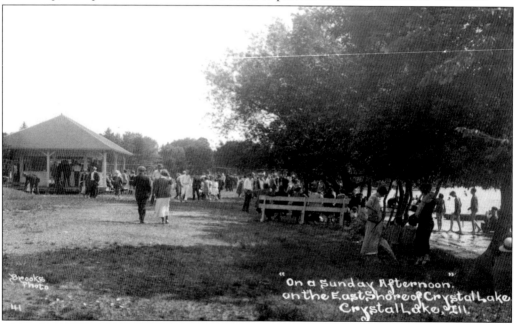

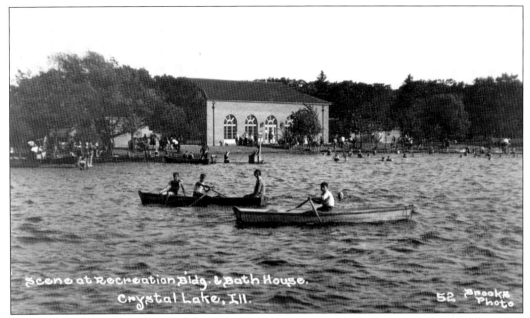

**RECREATION BUILDING AT MAIN BEACH.** A new recreation building was built and opened to the public in July 1926. Today it looks much as it did when first built. The brown brick walls and the mission tile roof are the same. The center section of the building measured 40 by 80 feet. This area was used for dancing and other forms of recreation. The original floor was made of concrete.

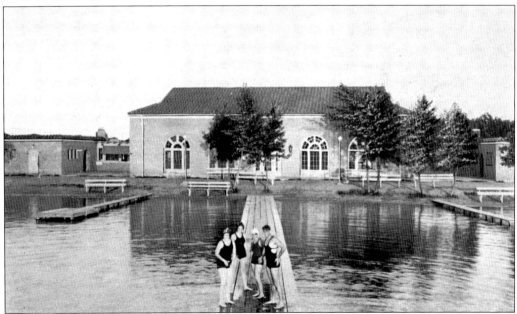

**BUILDING IS FURTHER DESCRIBED.** Tall, arched windows and doors graced the front and back of the building's center section. On each end of the main building were smaller rooms for concessions. The concession stands were accessed through an interior walkway or exterior window on the lake side of the building. The men's and women's locker rooms, showers, and public lavatories were also located on either side of the main room.

ROOM FOR EVERYONE, Parking Space, Crystal Lake Park District, Crystal Lake, Ill.    6009-6

**SWIMSUIT AND AUTOMOBILE REGULATIONS.** The *Crystal Lake Herald* reported that more than 100 swimming suits were rented the first weekend at a fee of 25¢ each. Rental for a locker was 10¢. Guests wishing to use their own swimsuit could either wear the suit to the beach or rent a locker, as they were not permitted to change into their swimsuits in the car.

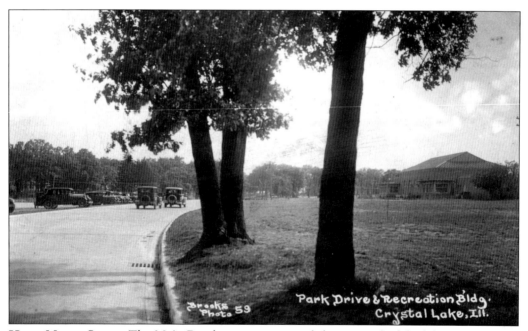

Park Drive & Recreation Bldg. Crystal Lake, Ill.

**HALF MOON STRIP.** The Main Beach property cupped the east end of the lake, much in the shape of a half moon. A new road was established to connect the beach property to both Dole Avenue and Lake Shore Drive (formerly West Street) near today's Leonard Parkway. Initially this was a gravel road, but it was paved a few years later.

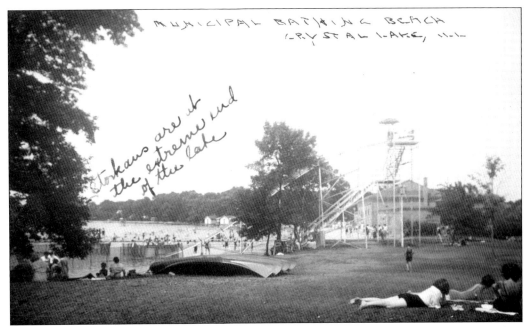

**WATER SLIDE AT MAIN BEACH.** The idea of installing a water slide at Main Beach was first proposed by the American Legion in March 1928. The legion proposed to erect the slide but needed park district approval. Apparently, no action was taken at the time. In 1931, the park district purchased a water slide from Louden Playground Equipment Company for $1,220. Two years later, it was determined that the water slide was dangerous and not practical. The slide was then cut down and converted into a winter toboggan slide. For more than a dozen winters, youngsters enjoyed the toboggan slide at Main Beach. In 1950, the slide was condemned and dismantled.

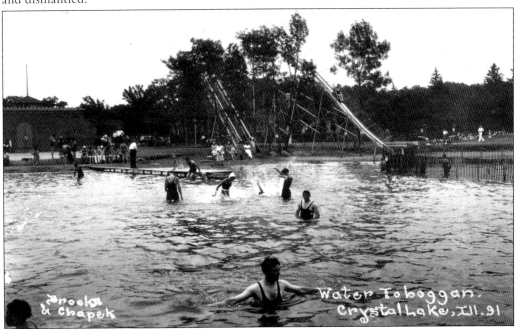

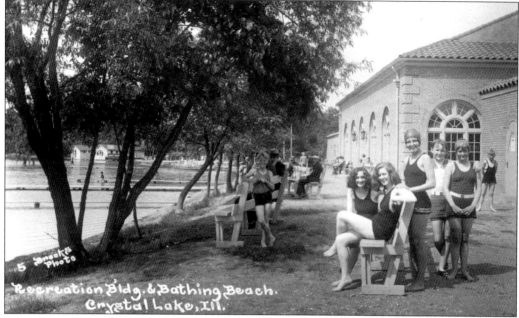

**RELAXING AT THE BEACH.** Generation after generation of young people put on their swimsuits and spent countless days of swimming and sunbathing each summer at Main Beach. Beach use was not just for the young people, as residents of all ages stopped by and enjoyed the peace and beauty of Crystal Lake.

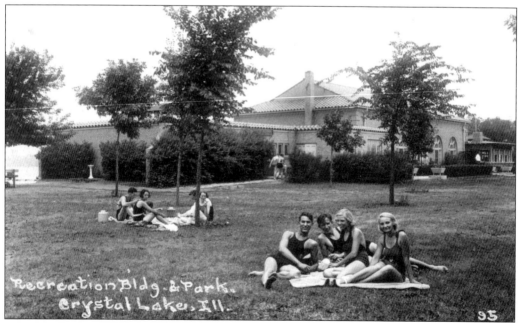

**LARGE PARK PERFECT FOR PICNICS.** The grassy area surrounding the Main Beach recreation building offered some of the best locations for an afternoon picnic with friends. Large trees growing throughout the park provided plenty of shade. Guests could bring their own blanket and picnic food or purchase items from the concession stand.

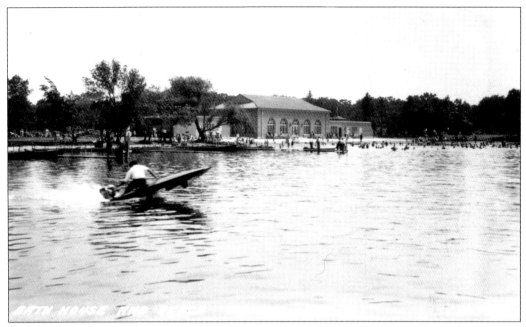

**BOATING ON CRYSTAL LAKE.** For many years, sailboats and rowboats provided a quiet, relaxing ride on Crystal Lake. Beginning in the late 1920s, motorboat use on Crystal Lake grew in popularity. In response, early regulations restricting proximity to shore, speed, and use of mufflers on the motors were quickly enacted.

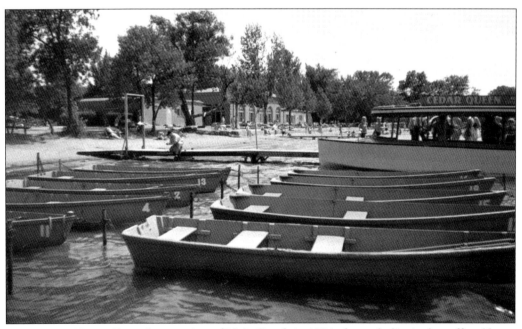

**BOATS FOR HIRE.** Since the opening of Main Beach in 1926, the park district has offered boats for rent. Through the years, several private companies have received permission to give guided tours of Crystal Lake. In 1939, 25¢ was the cost of a ride around the lake on a boat called the *Clara Lou*. The *Cedar Queen* tour boat operated in the 1960s.

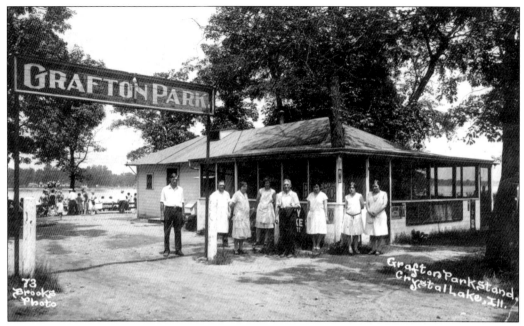

**GRAFTON PARK BEACH.** Crystal Lake stretches across both Algonquin and Grafton Townships. For many years, much of Crystal Lake's shoreline was in unincorporated McHenry County. Main Beach was located on the east end of Crystal Lake, but the west end also had its own public beach, a park, piers, and a bathhouse. This was known as Grafton Park and was owned and operated by the Grafton Park District. The bathhouse shown in these images included a men's and women's washroom/locker room and a concession stand. The concession stand was run by private parties that competed each year for this privilege.

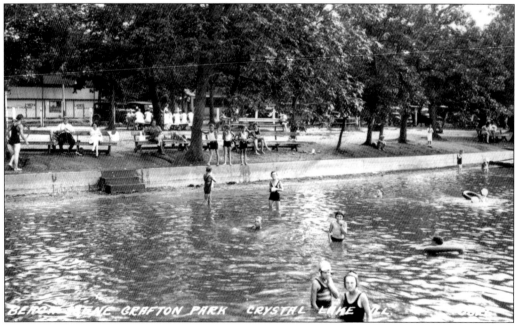

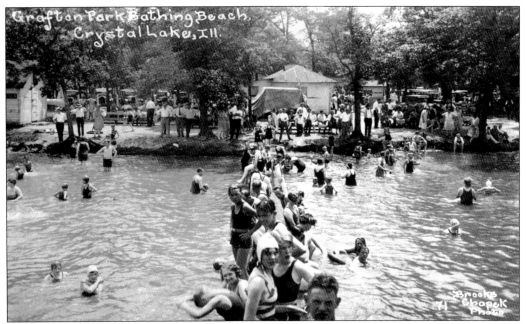

**GRAFTON PARK, C. 1932.** The Grafton Park bathing beach was extremely popular for locals and out-of-town guests. Residents of Grafton Township were given free passes to use the beach. Nonresidents often flocked to the beach on weekends, paying a minimal fee to use the lake. This surge of visitors was the source of numerous complaints about the lack of parking and overcrowding.

**CHANGES AT GRAFTON PARK.** In 1941, a new building was erected at Grafton Park. In addition to the standard washrooms/locker rooms and concession area, the new building included a kitchen and two meeting rooms. In 1968, Grafton Park merged with the Crystal Lake Park District and was renamed West Beach.

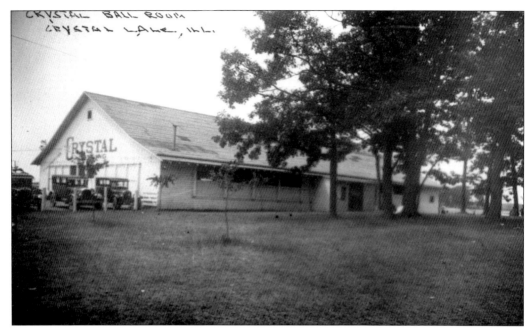

**THE CRYSTAL BALL ROOM.** Just west of Grafton Park stood another lakefront building called the Crystal Ball Room, which was constructed in the 1920s. This popular pavilion was the site of many dances and parties. The *Crystal Lake Herald* reported in 1938 that Friday night crowds ranged from 700 to 1,100 people, all gathered to dance to the tunes of a popular orchestra. After World War II, the Crystal Ball Room was also used as a roller-skating rink and outdoor movie theater. It was affectionately known as "the Hog Rassle." The village of Lakewood acquired the property in 1955. The building was remodeled and used as a municipal center. In 1978, the old building was razed and a new village hall and police station was built.

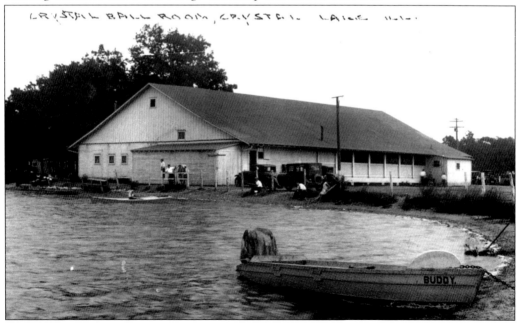

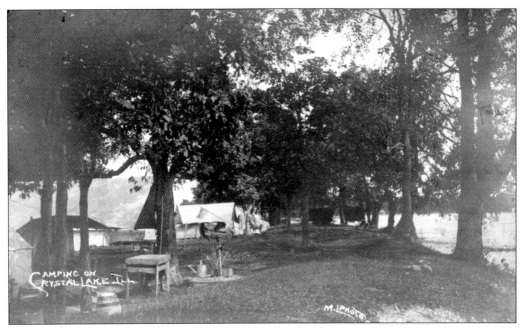

**CAMPING AT CRYSTAL LAKE.** The earliest settlers of Crystal Lake set up camp near the shoreline, as the lake was a source of fresh water and food. Eventually camping at Crystal Lake became more of a leisure activity. Organized camps were also established on the west end of the lake, with names such as Camp Sokol, Camp Lidice, Camp Bob, and even a Boy Scout camp.

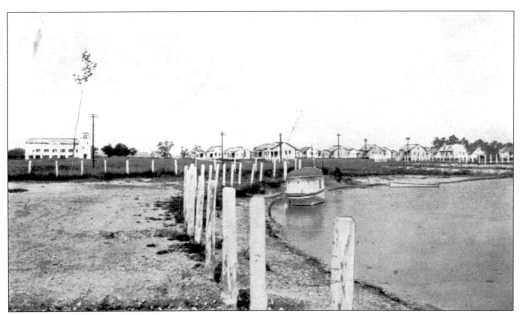

**COTTAGES AND A CLUBHOUSE.** Small cottages were built primarily on the west and north shores of Crystal Lake. These cottages were rented out for a week, a month, or the summer season. The large white building (left) is the Crystal Vista Clubhouse, which was located near today's intersection of North Avenue and Briarwood Road. The clubhouse opened in 1927 but was foreclosed on and abandoned by the mid-1930s.

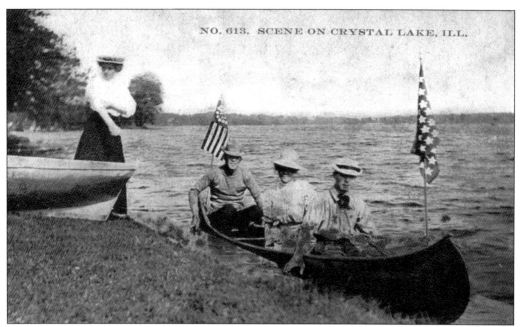

**BOATING ON CRYSTAL LAKE.** Since the early days, visitors and residents have enjoyed boating on Crystal Lake. The above postcard shows two young men and two young women venturing out in a canoe. Flags are proudly mounted at the front and back of the canoe. The postcard below shows a sailboat on Crystal Lake also sporting a flag. This photograph was taken from the north shore of Crystal Lake, looking across the water to the south shore. A close look at the south shore reveals two of the large icehouses that were still standing in 1910 when this photograph was taken (see chapter 7).

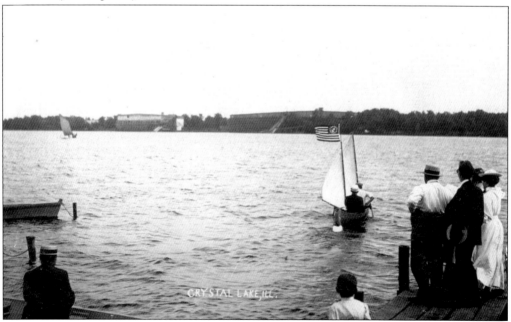

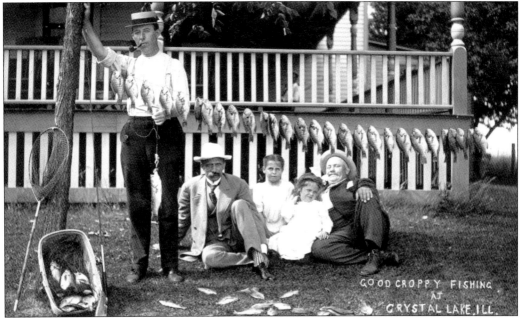

**GOOD FISHING IN CRYSTAL LAKE.** The above postcard shows a multigenerational family deservedly proud of its fishing catch. The front caption indicates, "Good Croppy Fishing at Crystal Lake." The postmark date is 1908. The postcard below shows two strings of fish that would make any fisherman proud. Crystal Lake is home to many types of fish, including northern pike, walleye pike, musky, small- and large-mouth bass, black crappie (croppy), blue gill, yellow perch, and catfish. Many big fish, including a 33-inch northern pike, have been pulled from the lake, and more than one incident has been reported of musky greater than 50 inches long being caught by local fishermen.

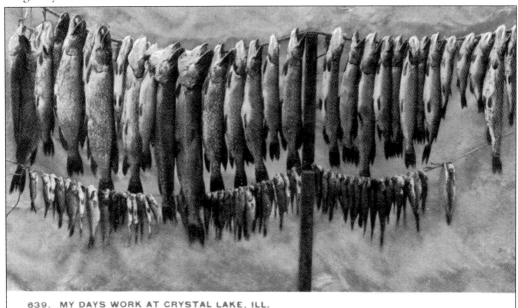

treet Scene, Crystal Lake, Ill.—C 1

**CRYSTAL LAKE'S ORIGINAL PARK.** The original plat of survey for the village of Crystal Lake was completed in 1840. The public square was clearly marked and bounded by Florence, Virginia, King, and Park (Pierson) Streets. The park was originally known as simply the public park. This very early postcard image of Virginia Street (Route 14) was taken about 1904 and shows a dirt road with horses and wagons. The public park is on the left-hand side of the road. In the 1930s, the name was changed to Pierson Park to honor early citizen and civic leader James T. Pierson. In 1955, the name was changed again to its current title, McCormick Park, in honor of Fr. Edwin A. McCormick, who served St. Thomas Church for many years. The three-story building in the background (now demolished) was known at that time as Fitch's Brick Block building.

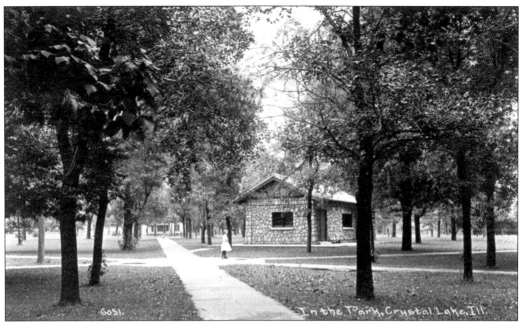

**THE PUBLIC PARK.** The public park was laid out with numerous walking paths crisscrossing the grounds. Other early images show people walking, pushing strollers, and riding bicycles along the park paths. The large grassy lawns and tall shade trees provided a pleasant oasis for community gatherings and picnics. The stone building featured in these images was built in the early 1900s as a pump house. Equipment inside the pump house helped to supply residents with clean, fresh well water. For a few years, the building was used as a meeting place for the Crystal Lake Village Board. The shell of this old village pump house still remains as the nucleus of today's chamber of commerce building.

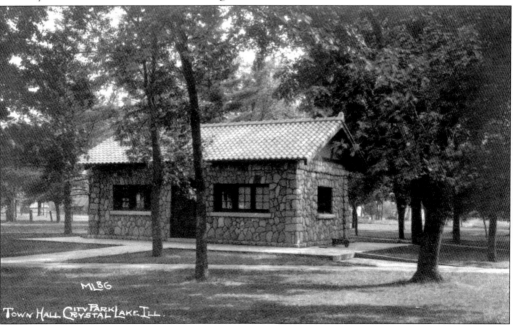

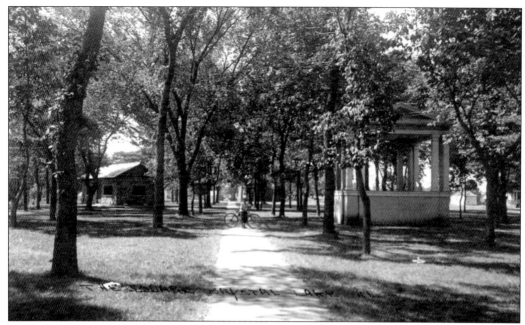

**BANDSTAND IN THE PARK.** As early as 1893, a bandstand was situated in the public park. For many years, the city band performed at this location, entertaining local citizens. The bandstand was located on the west side of the park toward Florence Street, while the pump house was on the east side closer to King Street.

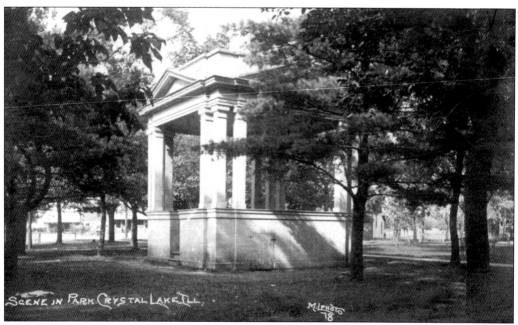

**BANDSTAND MEMORY.** A close inspection of the base of the bandstand shows a small door. According to a short history written by Jennie Ford in the late 1890s, the basement of the bandstand was the place for young people to go when they were "in need of the two lip salve." The bandstand was removed in the late 1940s.

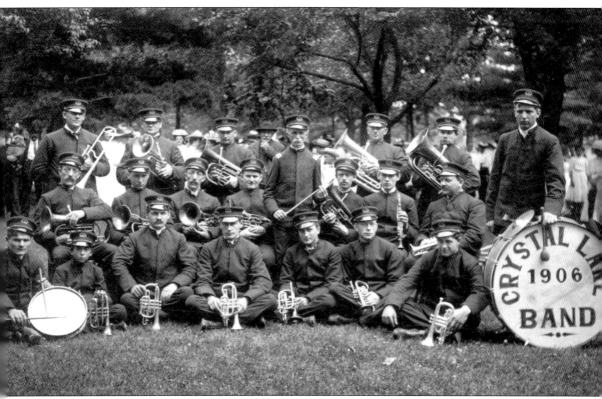

TOWN BAND PLAYS AT PARK. As early as 1906, the village of Crystal Lake had its own town band. The band was described in early newspapers as "a talented group and much in demand, having a very busy schedule of appearances." The band performed in the Crystal Lake village park and also at dance halls in Crystal Lake and nearby Nunda. Band members in this postcard image include, from left to right, (first row) Otto Kollenkark, Martin Ritt, P. E. Bertram, William Bruedigam, A. D. Abraham, J. Hue, and Walter Buehler; (second row) William Meier, C. F. Gumprecht, Herman Meier, William Kniebusch, Martin Roewer, Frank Kutschler, and George Wolck; (third row) Fred Long, Charles Sohst, Fred Wolck, director Livingston, August Peters, Fred Michaelis, and Frank Brockrogge.

"The School House Pond"—Nunda, Ill.

**VETERAN ACRES PARK.** The original Nunda School was located on the north side of Terra Cotta Avenue at the north end of Main Street. The nearby pond was part of a 130-acre site owned by the Walkup family and was commonly known as Walkup's Woods. The land was first claimed and settled by the Walkups in 1835. The property stayed in the family until the mid-1920s when it was sold for use as a par three golf course, known as Oakwoods Lodge. The golf course went out of business during the Depression. In 1939, voters approved the purchase of the property by the Crystal Lake Park District. The selling price was $20,000. In 1946, a contest was held to name the park. The name Veteran Acres Park, submitted by Luella Reddersdorf, was chosen by the judges as the winner of the contest. Reddersdorf received $100 for her winning entry.

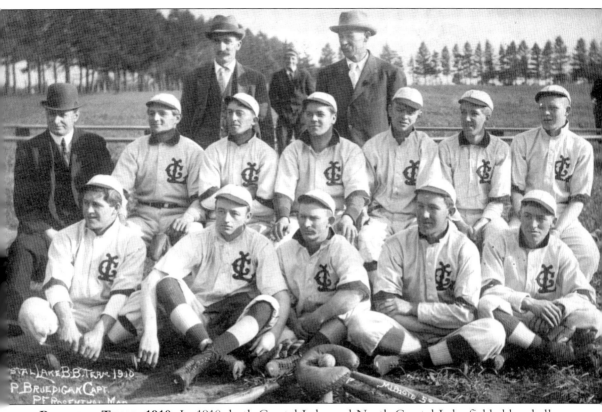

**BASEBALL TEAM, 1910.** In 1910, both Crystal Lake and North Crystal Lake fielded baseball teams. The teams competed against each other and other local community teams. Land was leased from J. A. Peterson, and the teams built and shared their baseball field, calling it Athletic Field. The Crystal Lake team proved to be the stronger of the two local teams, having a winning season of 18-6.

BASEBALL DIAMOND AT WALKUP PARK - CRYSTAL LAKE, ILLINOIS

**BASEBALL FADES AND REAPPEARS.** Enthusiasm for baseball in Crystal Lake faded with the onset of World War I. During the 1930s, local pharmacist Oscar Althafer led the charge to reestablish a team and build a baseball field at Walkup's Woods. Little League baseball came to town in the 1950s thanks to Frank Repp. In 1983, the baseball field at Veteran Acres Park was renamed Frank Repp Field in his honor.

# Seven
# BUSINESS AND INDUSTRY

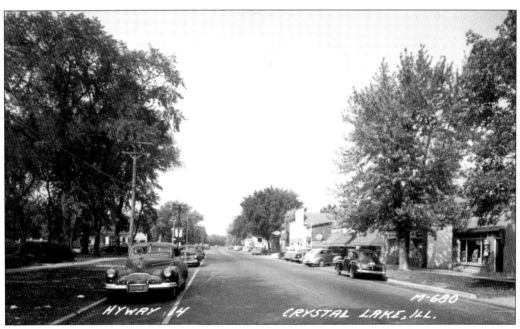

EARLY INDUSTRY. In the early days of settlement, most of the citizens of McHenry County were farmers. Once the railroads extended their lines through McHenry County in the mid-1850s, industry began to grow. This chapter features early industries of Crystal Lake and Nunda. The second half of the chapter features popular 20th-century businesses, primarily located on Crystal Lake's Route 14. (Courtesy of Jim Wyman.)

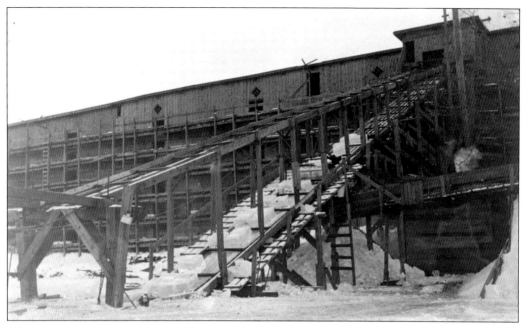

THE ICE INDUSTRY OF CRYSTAL LAKE. The crystal clear water of the spring-fed lake produced some of the finest ice in northern Illinois. In 1856, Amos Page ran the first commercial ice business called the Crystal Lake Ice Company. To ship the ice, Page constructed a railroad track from the lake to the downtown depot (along today's Dole Avenue). During the winter months, ice was cut from the lake, stored in large icehouses, and shipped by train to Chicago. In the 1870s, Charles and James Dole gained control of the lake and built 12 large icehouses. Icemen worked under brutal conditions, earning a pay rate of $1.50 per day in 1903. Only one fatality is recorded, that of George W. Irwin, who died in 1900. The last large icehouse on Crystal Lake burned down in 1914.

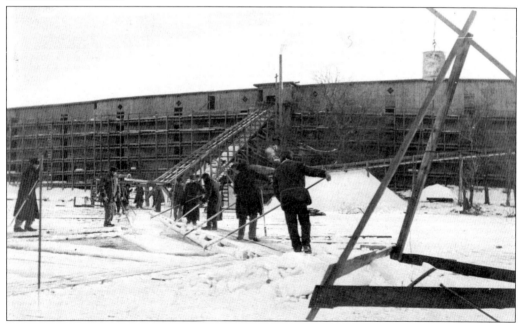

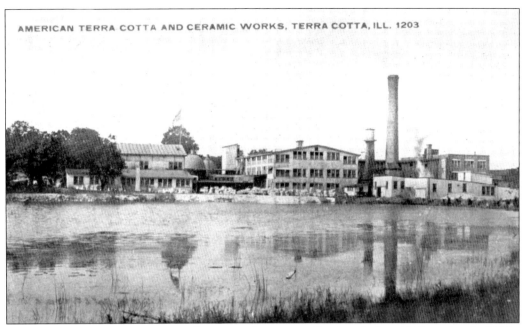

AMERICAN TERRA COTTA AND CERAMIC COMPANY. During the late 1800s and early 1900s, Crystal Lake enjoyed nationwide fame through the manufacture of architectural terra-cotta at the American Terra Cotta and Ceramic Company factory, which was located just a few miles northeast of downtown. The company was started by Crystal Lake resident William Day Gates. Carloads of architectural terra-cotta were produced and shipped out across the nation. Samples of the ornamental works can be found on many buildings in Chicago, including the famous Wrigley building on Michigan Avenue. Downtown Crystal Lake also has several buildings featuring the locally manufactured terra-cotta. In addition to architectural terra-cotta, the company also produced decorative pottery known as Teco pottery. Today these valuable ornamental vases are in demand as collectibles.

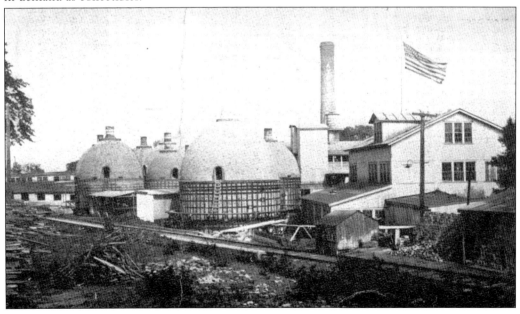

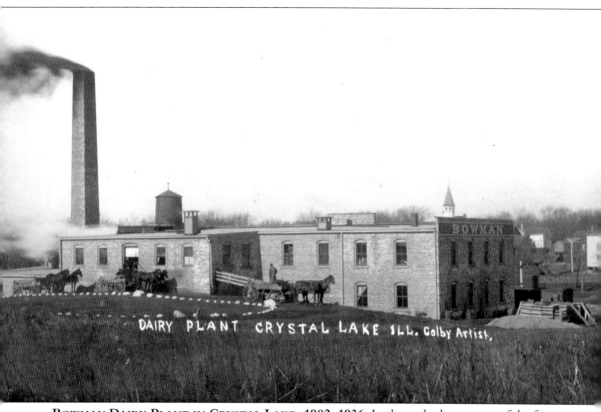

**BOWMAN DAIRY PLANT IN CRYSTAL LAKE, 1902–1936.** In the early days, many of the farms surrounding Crystal Lake were independent dairy farms. Each day, farmers brought their supply of milk to town to be processed, bottled, and distributed through various independent dairies. Bowman Dairy built this $40,000 milk-bottling factory in 1902. It was located on Main Street just south of the railroad tracks. This photograph shows the back side of the factory looking southwest. The church steeple in the background is the Methodist Episcopal church. Factors that encouraged Bowman Dairy to locate in Nunda included the ample supply of milk from nearby farms, proximity to the railroads and Chicago, low freight rates, abundance of pure ice, and a willing supply of local men for their labor force. In 1931, Bowman built a huge $1 million bottling plant in River Forest and began closing down operations at the Crystal Lake (Nunda) plant. Five years later, the plant closed its doors forever.

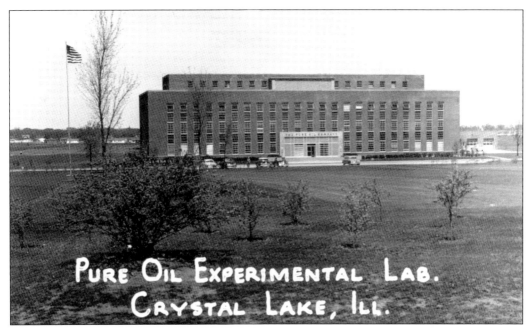

**PURE OIL EXPERIMENTAL LABORATORY.** In 1946, the Pure Oil Company purchased 68 acres of the old Rosenthal farm. The property was located at the northwest corner of today's intersection of Main Street and Route 14. By 1948, the company owned 140 acres of land and construction started for the largest building project in Crystal Lake's history to date.

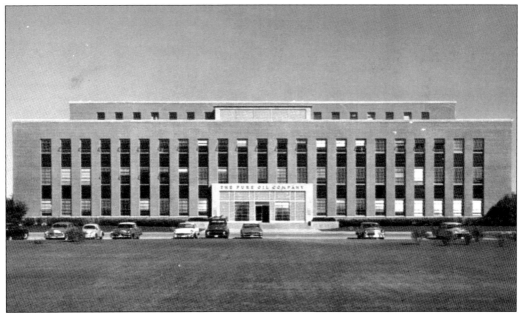

**PURE OIL COMPANY.** The plant housed the company's research and development staff and their many truckloads of valuable scientific engineering equipment. Six buildings occupied the Crystal Lake site, including a chemical engineering laboratory and automotive laboratory. Pure Oil closed its Crystal Lake operations in the 1960s. In 1967, the newly established McHenry County College occupied the site. The building was also used by the Illinois Institute of Technology.

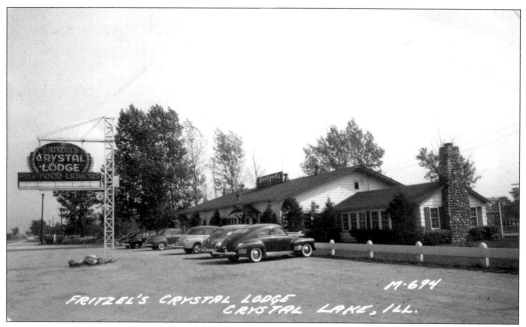

FRITZEL'S CRYSTAL LODGE RESTAURANT. George Fritzel purchased the Crystal Lodge in 1941 and renamed it Fritzel's Crystal Lodge. After his death in 1949, his widow, Margaret, continued to run Fritzel's Crystal Lodge for five years. It was sold in 1954 and was then known as Peterson's Lodge for three years.

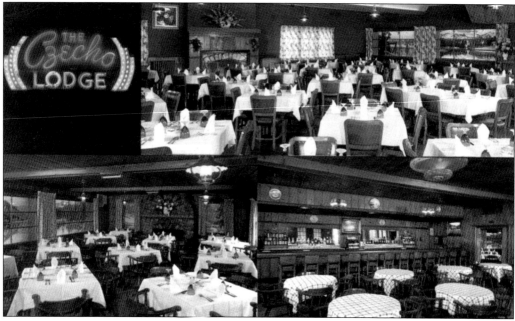

THE CZECHO LODGE. In 1957, Ray and Lucille Grossel purchased Peterson's Lodge and renamed it the Czecho Lodge. Lucille had active charge of the kitchen, while Ray tended bar. The Czecho Lodge featured Bohemian cooking and baking and was known for its superb food. In 1973, the restaurant was sold to John and Evans Archos, who renamed it the John Evans Inn. Walgreens drugstore currently occupies the site.

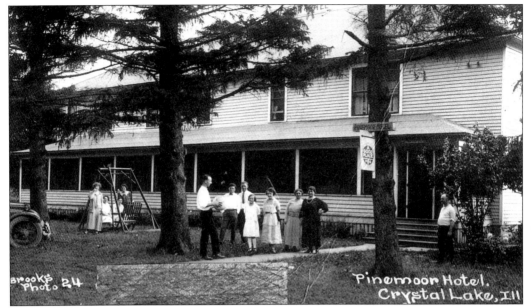

THE PINEMOOR HOTEL. The Pinemoor Hotel was located on Lake Street behind the Congregational church. The Pinemoor Hotel opened its doors in 1920 and was owned and operated by Chicago physician Dr. Otto Schlack and his sister May Schlack. In the early days, the Pinemoor Hotel was a place for honeymooners and vacationers. The hotel boasted a large screened-in porch, a restaurant, a bar, and clean, comfortable beds.

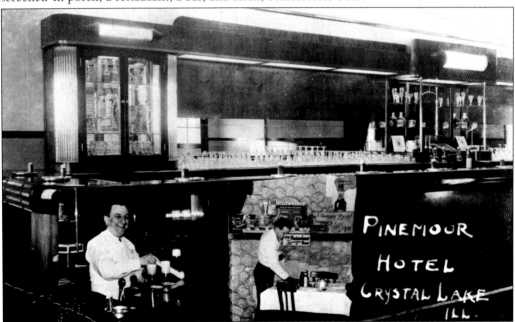

TRANSITIONS FOR THE PINEMOOR. In later years, the building's condition declined, and the hotel became more of a rooming house. By 1952, new fame came to the Pinemoor Hotel, as it became Crystal Lake's first pizza parlor. The bar and restaurant business still flourished until a disastrous fire destroyed the Lake Street building in 1982. Pinemoor Pizza then reopened at its current location on Route 14.

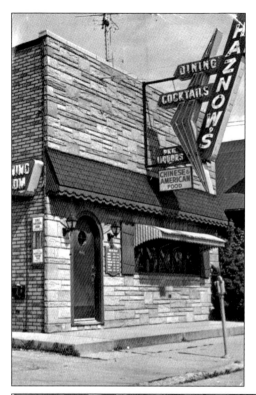

HAZNOW'S. Although neither of these images are taken from postcards, this history would be incomplete without mentioning Haznow's Restaurant and Bar on Virginia Street (Route 14). Frank "Doc" Haznow returned from World War II to join his father, John, in operating this bar and restaurant. Over the next 40 years, Haznow's grew to become a Crystal Lake institution. Haznow's was where the community gathered to be with friends and family, to celebrate occasions, or to discuss current events and issues. Doc teamed up with Sunny Eng to offer some of the best food in town. He tended bar and had an uncanny knack for making people feel good. The Chili Open golf tournament, which is played every winter on the frozen lake, is named after him.

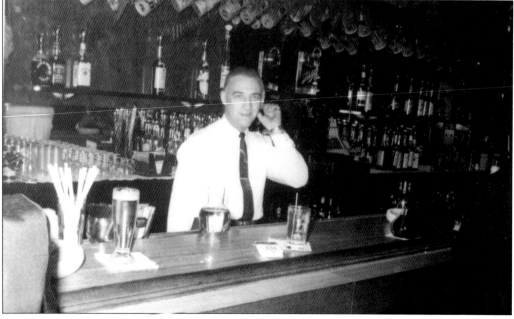

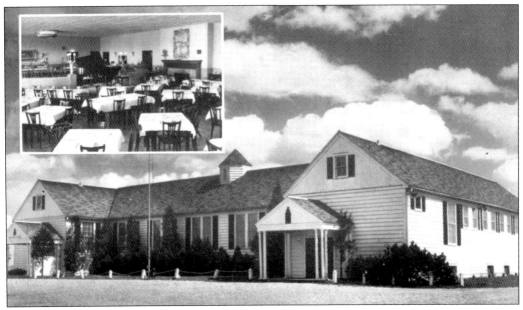

MARTINETTI'S FIESTA. Frank Martinetti purchased this building in 1946 for $30,000. Originally, the dining room, cocktail bar, and banquet hall were on the first floor. The basement had a dance floor. In 1950, the bar and restaurant were moved downstairs, and the first floor was remodeled into 17 hotel rooms and family living quarters. Disaster struck a few years later when the entire building burned to the ground.

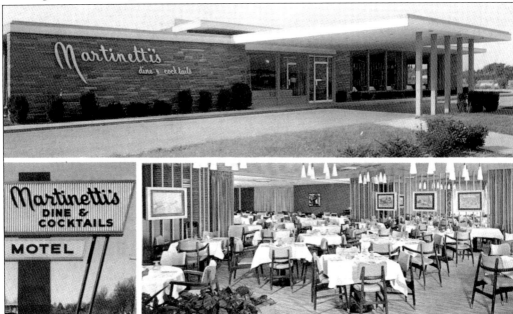

MARTINETTI'S RESTAURANT AND MOTEL. Martinetti's rebuilt on the same site in the late 1950s. The new Martinetti's featured a spacious restaurant, banquet facilities, and a cocktail lounge. Music from a large pipe organ entertained guests. A modern motel and 24-hour coffee shop occupied an adjacent building. The restaurant was later known as T. C. Spirits, September's, and Coleman's Place. The buildings were torn down in 1996 to make way for a car dealership.

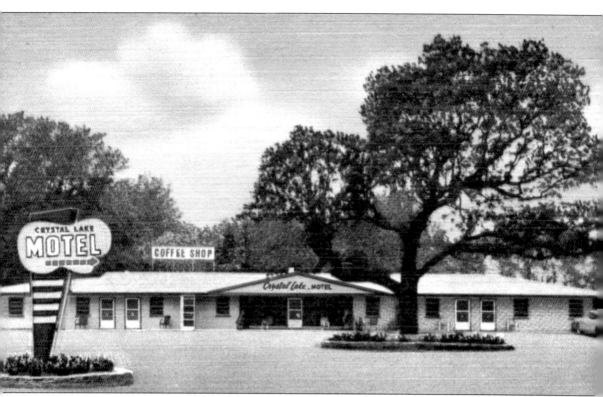

THE CRYSTAL LAKE MOTEL. Still located on Route 14 northwest of Lake Shore Drive, the Crystal Lake Motel and Coffee Shop was constructed in 1954 at a cost of $30,000. It was originally owned by Lakewood resident Paul Greenawalt. The motel had 16 units but soon expanded to 23 "ultra modern" units, each featuring its own television, radio, and Selec-temp steam heater. Other guest amenities included a children's play area and beach privileges.

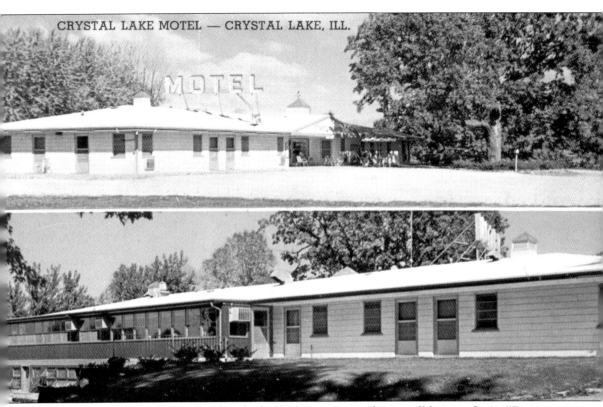

**DINING TERRACE.** The coffee shop had a dining terrace and was well known for its "Famous Danish Pancakes." The first registered guests of the motel came from Winnipeg, Canada, who arrived when the motel was not quite complete. The guests were tired and pleaded for accommodations. A room was quickly made ready, and the guests were permitted to stay.

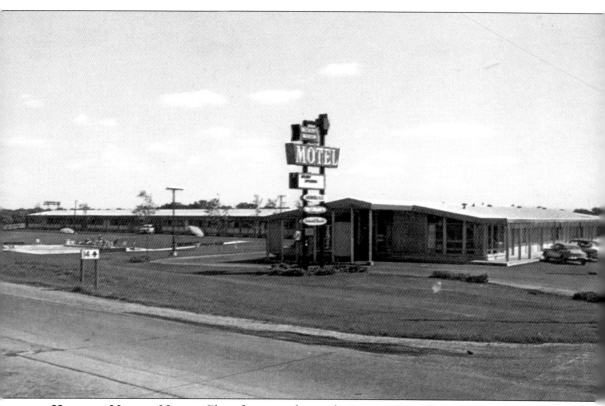

HICKORY MANOR MOTEL. Plans for a motel near the intersection of Route 14 and Route 31 were first discussed in 1954 when the neighboring manor subdivision was developed. Several years passed before the Hickory Manor Motel was actually built. The motel had 65 modern, air-conditioned rooms, suites, and kitchenettes. Other amenities advertised included switchboard service, complimentary continental breakfast, and even a swimming pool. The motel's slogan was "Tomorrow's Motel Today." By 1970, it was known simply as the Manor Motel and claimed to be the largest motel in McHenry County.

# Eight
# STREET SCENES

Residence Street, Nunda, Ill.—A 4

**HOME SWEET HOME.** Early street scenes of Crystal Lake show a variety of homes from unpretentious bungalows to large and imposing Queen Anne beauties. Each home represents a style or era from which it was built, and each home provides a glimpse into the past. Although some of these structures no longer exist, many of them remain to serve as silent reminders of the community's rich and interesting history.

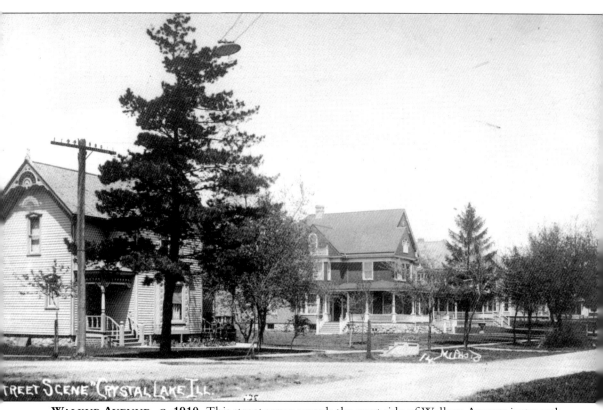

**WALKUP AVENUE, C. 1910.** This street scene reveals the west side of Walkup Avenue just north of Center Street. The corner house (left) was built about 1885 by Osman and Lurelia Hale. This duplex stayed in the Hale family for over a century. The small set of stairs at the corner parkway is a mounting block, commonly used to step up to mount a horse or enter a carriage. Osman's sister Helen Beach resided in a home across the street on the east side of Walkup Avenue. Beach's home was moved to South Caroline Street in 1980, effectively making way for Brink Street to connect to Walkup Avenue. Hale's Corner is the island of land formed by Brink and Minnie Streets and Walkup Avenue. Descendants of the Hale and Hamilton families donated money to put in a boulder, flowers, and trees on the site. The Countryside Garden Club maintains the garden at Hale's Corner.

**HALE HOUSES LINE WALKUP AVENUE.** The next house north was built in 1905 by Alva and May Hamilton Hale. Alva was the son of Osman and Lurelia Hale. The Hale house at 84 North Walkup Avenue is landmarked by the City of Crystal Lake and is an excellent example of Queen Anne architecture. The fieldstone foundation, decorative clapboard siding, and stained-glass windows depict a style of workmanship long gone. May's grandmother Arvilla Thomas lived in the house at 96 North Walkup Avenue, which was built in 1904. Thomas became the first casualty in an automobile accident in Crystal Lake. In 1910, she was riding in a pony rig with her granddaughter and great-grandson on McHenry Avenue near the Union School. The pony was startled by an automobile, and May, who was driving, lost control of the rig. The pony pulled the rig into the yard of Carl Jurs's home, crashing into the corner of the building. Thomas was thrown against the house. Her skull was fractured, and she died an hour later in her home.

**ALEXANDER J. DIKE'S RESIDENCES.** This view shows the south side of Crystal Lake Avenue mid-block between Walkup Avenue and Williams Street. Both homes in this view were once owned by Alexander J. Dike. Dike first came to McHenry County in 1865. He owned a large farm near Ridgefield, breeding Merino sheep and Morgan horses. By 1885, Dike retired from farming and moved into town. In 1905, he purchased the large house on the left. Soon after, he decided to build a second home just west of the first. This smaller house had a gambrel roof and fieldstone foundation. It became the Dike family's primary residence. Today the larger Dike house still stands and is used as a law office. The smaller Dike house has been demolished, and the land is currently a parking lot.

**CHARLES TECKLER'S RESIDENCE.** This view shows the south side of Crystal Lake Avenue just east of Walkup Avenue. The corner house on the right belonged to Charles Teckler. Teckler was known as "the dean of real estate" in Crystal Lake. Born in Germany, he came to Crystal Lake and earned a living by buying, selling, and developing property. After his first wife died, he married the girl next door, Carrie Dike, the daughter of Alexander J. Dike. Teckler family members were tireless workers for the First Congregational Church of Crystal Lake. For many years, Teckler was the Sunday school superintendent and later served on the board of trustees. Carrie conceived the idea of a women's club and hosted its first meeting in her home. Today the women's club is still an active part of the congregation and is known as women's fellowship. Teckler's obituary describes him as "one of the most remarkable men ever to reside in Crystal Lake."

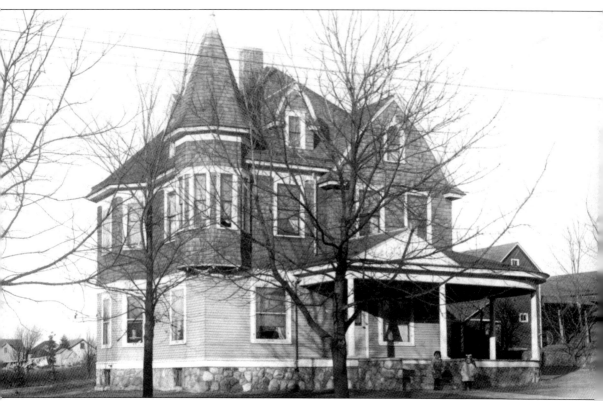

**Franklin E. Cox Residence.** About 1855, Franklin E. Cox came from New York with his parents and two brothers. The family settled on a farm that was located between Crystal Lake and Cary. He enlisted in the Civil War when he was 16 years old. After the war, he returned to McHenry County and married Ellen Mary Burton. Cox continued to work on the family farm for a few years but eventually gave it up and moved into the town of Nunda. He served as Nunda postmaster from 1884 to 1888, as an officer in the GAR (a Civil War veterans organization), and as village president in 1889. Ellen died of heart failure in 1902. The house shown in the photograph was located at the northeast corner of Crystal Lake Avenue and North Caroline Street. Cox built this home in 1904 as a wedding gift to his second wife, Katherine. Tragedy struck again when Katherine died in 1905. The house was then sold to A. W. Wiltberger. Many years later, it was demolished.

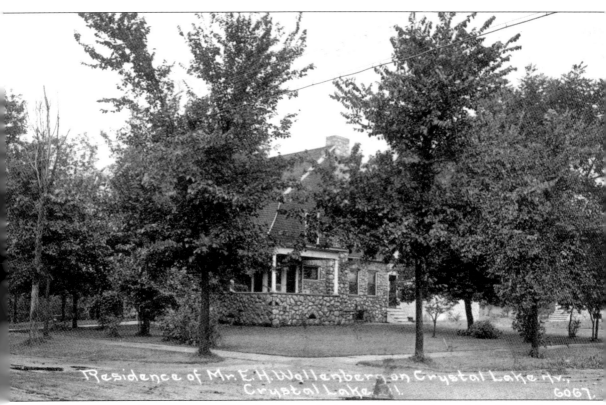

ELMHURST AND STONEHURST. This view shows the house named Elmhurst. It is still standing today at the northwest corner of Crystal Lake Avenue and Elmhurst Street. Early subdivision maps show Elmhurst Street was originally named Mechanic Street. Soon after the death of his second wife, Katherine, Franklin E. Cox purchased an entire block of the newly subdivided property of Walkup's Addition to Nunda. In 1905, he built a beautiful home on today's Elmhurst Street, calling it Stonehurst. The stonework on the house made it distinctive, and it was considered to be one of the handsomest buildings in town. Not resting, he rented this house and started work on a second stone house at the corner. In 1907, Elmhurst was completed, and Cox and his third wife, Mary, moved into their new home.

NORTH WILLIAMS STREET, C. 1920. Both of these images of Williams Street were taken looking north from Crystal Lake Avenue. The photographs reveal the south block of North Williams as a residential, tree-lined street. The first two homes on each side of the street remain today and are mixed business/residential use. Several other homes shown were moved to South Williams Street, and the remainders were demolished. The first house shown on the photograph below served as a doctor's office for many years. In the early years, it was owned by Dr. Harry D. Hull, who was elected twice as village president of Nunda/North Crystal Lake. Hull was instrumental in uniting the twin villages into today's city of Crystal Lake. After Hull's retirement, the home served as an office and residence for Dr. A. V. Lindberg.

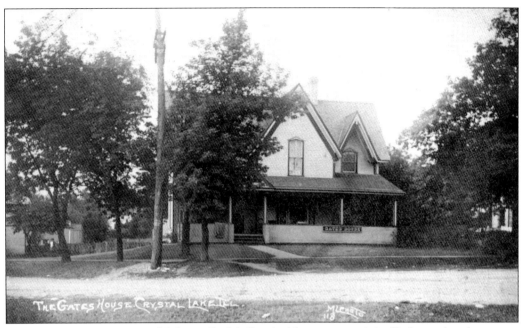

**BALLOU/GATES HOUSE.** This large Gothic Revival home was originally located at the corner of Main and South Railroad Streets (now Woodstock Street). The first owner was Dr. Emory Ballou, a prominent local physician. The spacious house was built about 1875 to accommodate Ballou's growing family and medical practice. The location close to the railroad made it easier for him to travel the county to visit his patients. After his death in 1907, the house was purchased by Louis Gates, who converted it to a hotel known as the Gates House. Ten years later, the house was moved to the southeast corner of Center Street and North Caroline Street, where it stands today. The Ballou/Gates house is currently a three-flat apartment.

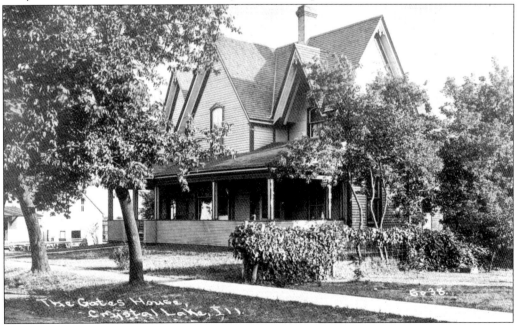

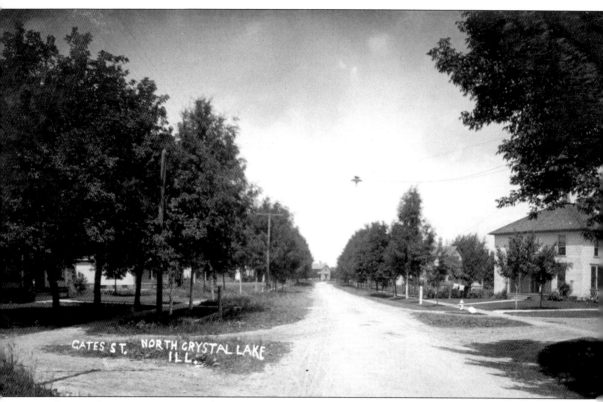

**GATES STREET, C. 1910.** This early view of Gates Street is shown looking northwest near the intersection of Second Street. A close inspection of the photograph shows a single-bulb streetlight suspended from wires strung across the street. Gates Street was named for Simon S. Gates. Gates first traveled from his home state of Massachusetts to McHenry County in 1838 or 1839. This journey was on horseback. At that time, he purchased large parcels of property but then returned to his home in Massachusetts to serve in the state legislature. In the early 1850s, Gates returned to Illinois with his wife, Sylvia, and three young children. The family lived on a farm near Crystal Lake and then later moved into town. Gates steadily purchased additional properties throughout the area and soon became one of the largest landed estate owners in the county. At the time of his death in 1879, his estate was valued at over $500,000, a huge amount of money for that time.

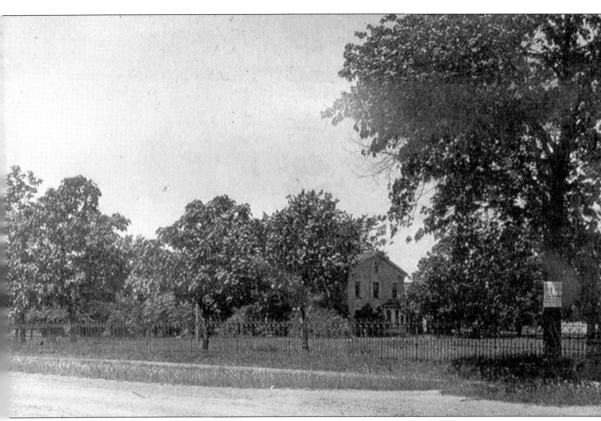

CRYSTAL LAKE ACADEMY/GATES HOUSE. This view of 210 McHenry Avenue was taken around 1915. It shows the Crystal Lake Academy/Gates House, which is currently part of St. Mary's Episcopal Church. The black iron fence still stands on the edge of the property along McHenry Avenue. A close inspection of the sign posted to the tree (far right) indicates the property is for sale and C. L. Teckler is the realtor. The Crystal Lake Academy was built about 1852 and is of the Federalist Greek Revival style. The academy was a private school attended by young people from prominent early families. The Free School Act of 1855 provided free education to all children. Shortly thereafter, the academy failed financially. The building and surrounding six and a half acres of land were acquired by Gates. The Gates family then moved into the house, retaining ownership for nearly 30 years. (Courtesy of Major F. Gates.)

**ILLINOIS ROUTE 31**. Both of these postcards (dated 1929 and 1942, respectively) show Illinois Route 31 between Crystal Lake and McHenry. The steep incline was commonly referred to as Terra Cotta Hill, due to its location near the American Terra Cotta and Ceramic Company factory. Terra Cotta Hill most certainly provided a challenge to the earliest automobile engines.

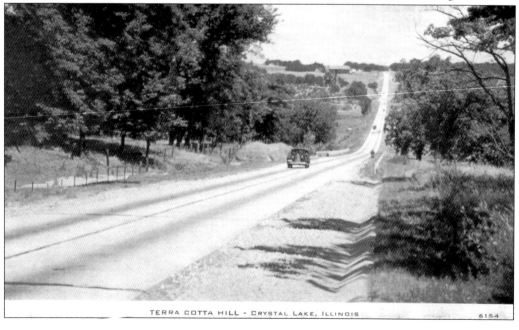

COBBLESTONE HOUSES IN CRYSTAL LAKE. During the mid-19th century, local stonemason Andrew Jackson Simons built several cobblestone houses and building foundations throughout Crystal Lake and Nunda. Two of his cobblestone houses are still standing: the Columbus Wallace house on Virginia Street and the John B. Walkup house on North Walkup Avenue across from Veteran Acres Park. A third cobblestone house built by Simons was the James T. Pierson house, which is shown in this photograph. Pierson lived in Crystal Lake from 1840 to 1872. He was a charter member of the First Congregational Church. Pierson Street is named in his honor. After leaving Crystal Lake, Pierson moved to Clinton, Iowa, where he was elected mayor. The Pierson house was located on Virginia Street just west of Dole Avenue. It was demolished in the early 1960s and replaced with a brick telephone company building. Other buildings revealing Simons's cobblestone masonry include the Crystal Lake Academy/Gates House (now owned by St. Mary's Episcopal Church) and the Col. Gustavus A. Palmer house.

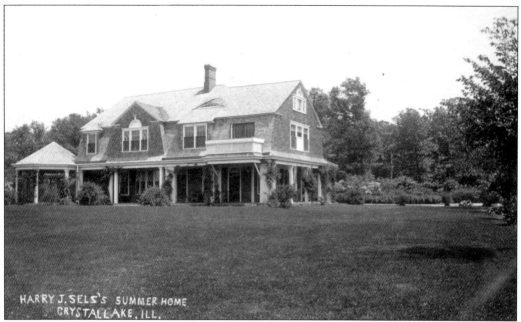

**SELZ SUMMER HOME ON LAKE.** In 1871, Morris Selz started a shoe business in Chicago. The Selz shoe business was in its peak around 1900, with several shoe factories throughout the country, including in Chicago and Elgin. In the early 1890s, Selz's sons J. Harry Selz and Emmanuel Selz purchased 39 acres of land from the James Crow estate on the northeast shore of Crystal Lake. The Selz family lived in the Crow mansion on Lake Shore Drive. The Selz home shown in these photographs was built around 1900 as a lakefront summer home on today's Woodland Drive. In 1924, the Selz lakefront home was winterized, and the family lived there year-round. The house remained in the Selz family until 1950. It was demolished in the 1990s.

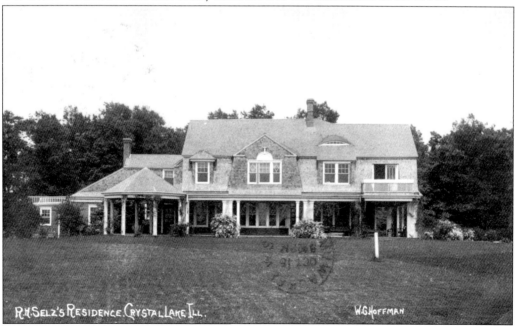

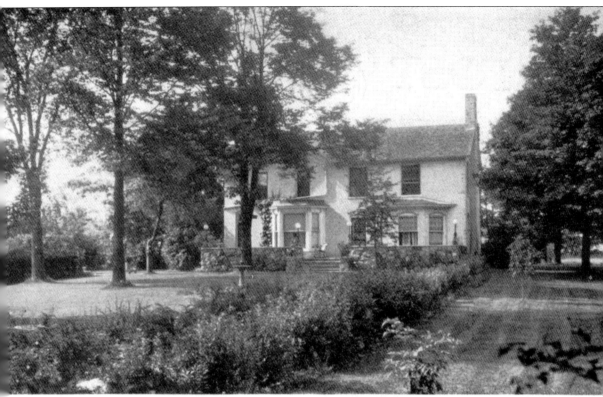

RESIDENCE OF A. C. ROEBUCK, CRYSTAL LAKE, ILL. 643

**HOME OWNED BY CATALOG GIANT.** This Civil War–era home sat on 10 acres of land for nearly 40 years before the property was subdivided. Today the home sits on a three-acre parcel on Woodstock Street just east of Oak Street. Through its 140 years of existence, the house has undergone several renovations, remodelings, and additions. One of its earliest owners was George Clayson, who purchased the property in 1882. During Clayson's ownership, the property became a fruit farm, with grape, raspberry, and strawberry plants and cherry, pear, and apple trees. From 1908 to 1916, the property was owned by Ernest E. Booth. Booth called his estate the Maples. The most famous owner of this house was Alvah C. Roebuck, who was cofounder of the firm Sears and Roebuck. Roebuck owned the property from 1916 to 1918. Today the property still boasts a fabulous carriage barn. Also found outside the home is a mounting block, which provided a step up to mount a horse or enter a carriage.

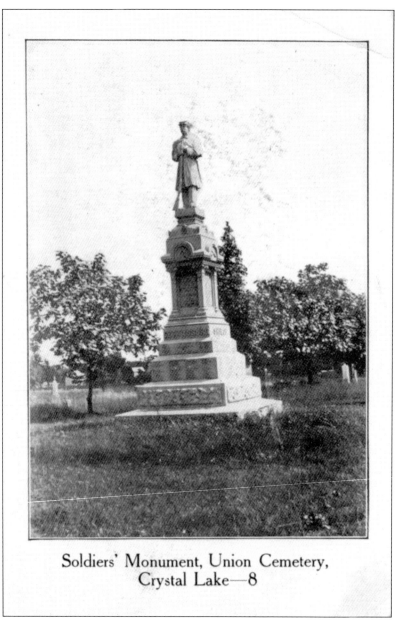

Soldiers' Monument, Union Cemetery, Crystal Lake—8

UNION SOLDIER STATUE. Just off Woodstock Street in the heart of Crystal Lake stands a faithful Union soldier, cast in zinc, who has been steadfastly on guard for nearly 120 years. He has performed the mission assigned to him on September 11, 1889, when, according to the plaque on his base, he was "erected by grateful citizens, in honor of the brave defenders of our country." While this monument was originally intended to pay tribute to veterans of the Civil War, it has also served as a reminder of selfless sacrifice and heroism for subsequent generations. The years have not been easy on this Union soldier. The structural integrity of the statue has been compromised by exposure to the elements. By 2007, the figure of the soldier was leaning back in such a precarious position that the statue was taken down before it fell down and was irreparably damaged. Funds are being raised by the Crystal Lake Historical Society to repair the statue and return him to this place of honor.

# About the Society

CRYSTAL LAKE HISTORICAL SOCIETY. All the author's royalties from the sale of this book will benefit the Crystal Lake Historical Society, a not-for-profit organization, whose mission is "to identify, preserve, present and promote the history of Crystal Lake, Illinois." Please visit the society's Web site at www.cl-hs.org to learn additional information.

## Across America, People are Discovering Something Wonderful. *Their Heritage.*

Arcadia Publishing is the leading local history publisher in the United States. With more than 3,000 titles in print and hundreds of new titles released every year, Arcadia has extensive specialized experience chronicling the history of communities and celebrating America's hidden stories, bringing to life the people, places, and events from the past. To discover the history of other communities across the nation, please visit:

# www.arcadiapublishing.com

Customized search tools allow you to find regional history books about the town where you grew up, the cities where your friends and family live, the town where your parents met, or even that retirement spot you've been dreaming about.